IMAGES
of America
MERIDEN

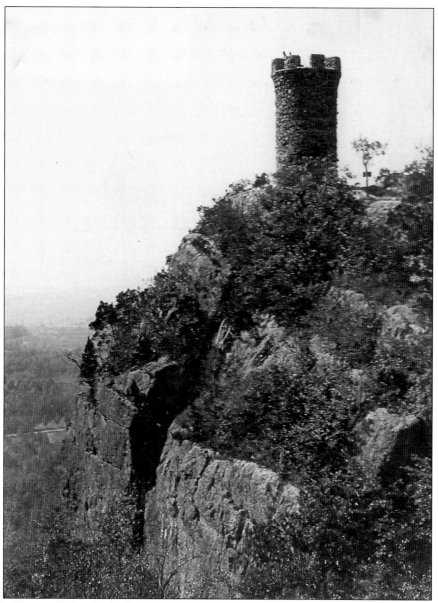

Castle Craig, a 32-foot-high observation tower, was given to Meriden in 1900 by Walter Hubbard. More than 1,000 feet above sea level, the tower provides spectacular views of the city and surrounding countryside. It is assumed that Hubbard was inspired to build it after viewing European castles. His draftsman, Stuart Douglass, created the design. In late spring, summer, and early fall, it is possible to drive to the tower. (Courtesy of Meriden Public Library.)

ON THE COVER: Planning for the June 1906 centennial of the incorporation of Meriden as a town went on for more than a year. Starting with services in all of the churches on Sunday, June 10, the town held parades, sporting events, exhibits, and concerts. A 400-page illustrated report described the successful week-long celebration. In this parade photograph taken on State Street, the factories of International Silver Company are visible in the foreground. (Courtesy of Meriden Public Library.)

IMAGES
of America

MERIDEN

Janis Leach Franco

ARCADIA
PUBLISHING

Published by Arcadia Publishing
Charleston SC, Chicago IL, Portsmouth NH, San Francisco CA

Printed in the United States of America

Library of Congress Control Number: 2010920398

For all general information contact Arcadia Publishing at:
Telephone 843-853-2070
Fax 843-853-0044
E-mail sales@arcadiapublishing.com
For customer service and orders:
Toll-Free 1-888-313-2665

Visit us on the Internet at www.arcadiapublishing.com

CONTENTS

ACKNOWLEDGMENTS

Thank you to the many wonderful people of Meriden who continue to teach me about its history, especially Ken and Louise Cowing, Dorothy Daly, Arline Dunlop, Allen and Neda Weathers, and the members of the Meriden Historical Society. Additional thanks are owed to those who passed before, particularly Cecilia Caneschi, Warren F. Gardner, Roger King, Richard McBride, Rita Piccifochi, Lois Scofield, and Joh D. "Bub" Shaw.

Meriden is fortunate to have a community newspaper that reports on its activities. The paper has served for over a century by providing an historical record for the city and the surrounding communities. To the staff of the *Record-Journal* and its predecessors, thank you very much.

Thanks also to Hilary Zusman of Arcadia Publishing for providing valuable editorial assistance.

The encouragement and help of director Karen Roesler and the staff of the Meriden Public Library is greatly appreciated. Unless otherwise noted, all images are from the local history collection of the Meriden Public Library.

INTRODUCTION

Originally a hunting ground for the Mattabaset and Quinnipiac Native Americans, permanent European settlers have been in Meriden since the 1660s, when Jonathan Gilbert was granted 350 acres of land by the Connecticut colony. His tenant Edward Higbee was the first occupant, with Gilbert's son-in-law Andrew Belcher later purchasing the acreage and operating an inn on the property in the northern sector. Incorporated as a town in 1806, prior to that Meriden was a sector of Wallingford, having become a separate ecclesiastical parish when there were about 35 families in residence. The residents in the North Farms area found it difficult to make the trek to Wallingford on Sundays and so petitioned in 1727 to erect their own congregational meetinghouse on what is now Ann Street, on the east side of the then-predominantly rural town.

By the June 16, 1806, date of incorporation, there were over 1,000 residents. The Broad Street district, formerly known as Market Street, evolved to serve as the center of town affairs, with the Central Hotel an important stagecoach stop and hub at the corner of East Main and Broad Streets. After the 1838 advent of the railroad, the west side of town advanced as the center of business and commerce, with Colony and West Main Streets developing into a busy shopping district. The intersection of the two streets was known as "the Corner." In 1867, when the population was fewer than 9,000 people, Meriden was chartered as a city. Industrialist Charles Parker served as the first mayor. In 1980, the mayoral form of government was changed to a city manager system, and it remains so today.

Centrally located in New Haven County, halfway between Hartford and New Haven, Meriden became an early manufacturing center for items such as cut nails and ivory combs. The Quinnipiac River and its tributaries made water-powered mills possible. In 1808, pioneer pewter-maker Ashbil Griswold moved to Meriden where he made spoons, plates, and hollowware, which Yankee peddlers sold throughout New England. Griswold prospered, and soon britanniaware and then silver-plated products were being manufactured in town. In 1898, the International Silver Company was formed from more than a dozen independent silver firms. The company's success and prosperity led to Meriden being dubbed "the Silver City of the World." Numerous other locally produced items have included porcelain, glassware, ball bearings, small appliances, lamps, firearms, bells, candy, machinery, jewelry, casters, coffee grinders, piano stools, and musical instruments. Construction and printing were also important trades. For its support role in World War II, in 1944, the city was named the "Ideal War Community" by the War Manpower Commission. Meriden was also considered an ideal place to live and work; small enough to feel welcoming and friendly, large enough to have cultural amenities and include excellent education, business, communication, transportation, and recreation facilities.

The surrounding landscape composed of dramatic traprock ridges towering above hills, valleys, and swamps gave rise to descriptive and picaresque names such as Beaver Dam Brook, Cat Hole, Lamentation Mountain, Dogs' Misery, and Cold Spring. Other place names reflect the history of long-gone city residents and benefactors, many of whom built enduring mansions. Charles

Parker; Nathaniel Bradley; Ira Twiss; the Curtis, Ives, and Lewis families; and a host of others are reflected in street names that endure. Immigrant workers contributed vitality and variety to the life of the town.

A number of well-known people were natives or resided in Meriden. Gen. Walter Booth (1791–1870) of the Connecticut militia, who served as a U.S. representative, lived and died in town, being buried in East Cemetery. He was active in both town and state politics. Connecticut governor Abiram Chamberlain, longtime resident, served as president of the Home Bank and is buried in Walnut Grove Cemetery. Renowned opera soprano Rosa Ponselle was born in Meriden, as was composer Benjamin Homer (née Hozer), best known for the tune "Sentimental Journey." Composer and teacher Edwin O. Gerschefski (1909–1992) also came from town. Walt Solek (1911–2005), nicknamed the "Clown Prince of Polka," was from Meriden. Natives Gary Burr, Rob Hyman, and Tobi Driver continue to enrich the music world. Actors Humphrey Davis (1912–1987) and Beau Billingslea were both citizens. Author and radio personality Philips H. Lord (1902–1975), who created the character of Seth Parker, lived in Meriden. Authors George Sklar, Mary McGarry Morris, Tomi dePaola, and Laura Van Wormer have all called Meriden home. Popular poetess Ella Wheeler Wilcox resided in the city for a time and composed a poem for the first issue of the *Meriden Daily Journal* newspaper in 1886. Nurse Martha Franklin, founder of the National Association of Colored Graduate Nurses in 1908, was a native, as was notable cultural anthropologist George P. Murdock (1897–1985). The baseball world has benefited from residents Jack Barry (1887–1961), Mickey Stratton, Gary Waslewski, "Big Ed" Walsh (1881–1959), and Connie Mack (1862–1956), who first played ball with the semi-professional Meriden Resolutes. Golf champion Jerry Travers (1887–1951) lived in town and is buried in Sacred Heart Cemetery. Boxer Louis "Kid" Kaplan lived and fought here, as did wrestler Julius "the Great Mephisto" Woronick. Tennis champions Lois Felix and Bud Schultz hail from Meriden. The art world has been enriched by Meridenites Nicholas Scalise (1932–2009), Charlotte Sternberg (1920–2003), cartoonist Warren Sattler, and sculptor Louis Gudebrod (1872–1961).

With the decline of the silver industry and the rise of imported products, Meriden, like many American cities, had to overcome the loss of manufacturing jobs. The building of a still successful west side shopping mall contributed to the decline of the downtown business district, but the development of an industrial park on the east side encouraged new business. Today several of the oldest city companies continue operation, and modern technology firms have moved in. The annual daffodil festival in Hubbard Park attracts thousands of visitors in April, and the park remains a year-round sanctuary for nature lovers. Now with a population of almost 60,000, the city in the pleasant valley remains an opportune place to work and live. It is still a place where one can take advantage of city life, but have the beauty of the countryside nearby.

One

THE SILVER CITY

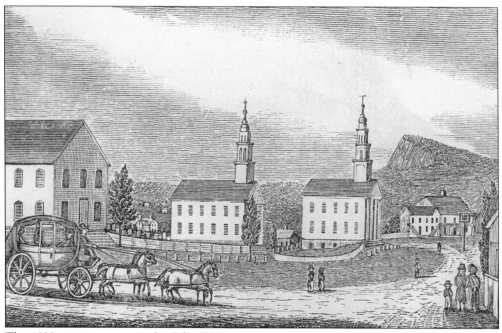

This 1830 engraving appeared in John Warner Barber's *Connecticut Historical Collections*, in which Meriden was described as "one of the most flourishing and enterprising manufacturing towns in the state." Depicted are, from left to right, the former Episcopal, Baptist, and Congregational churches on Broad Street. In the distance is the Central Hotel. Being equidistant from Hartford and New Haven, the tavern was a convenient stop for stagecoaches.

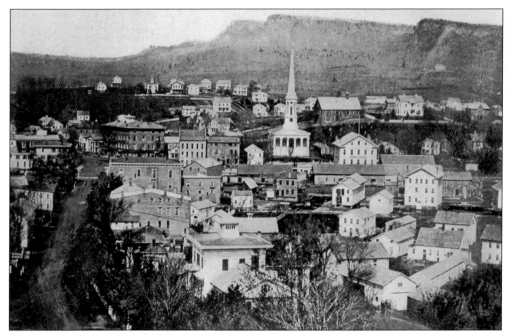

In this west-facing view of 1864, the Old Corner Congregational Church is prominent in the center of the photograph. It was built in 1849; the fourth church of the First Congregational Society. The Meriden House on the northwest corner of Colony and West Main Streets is also recognizable. The railroad crossing can be seen on Main Street, and the Hanging Hills dominate the skyline.

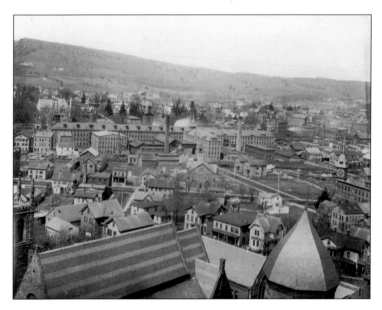

Smokestacks and large factories occupy this westward view of 1895. The long factory in the center is Meriden Britannia Company on State Street. To the right can be seen the clock tower of the Manning Bowman factory. In the left foreground is the striped roof of St. Andrews Church, and on the right is the roof of the first Meriden High School, which now houses the board of education.

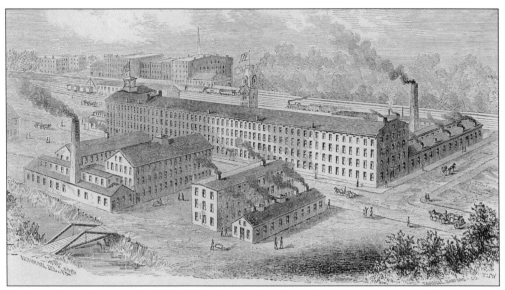

Meriden Britannia, or "B Company," was established in 1852 by Horace C. and Dennis C. Wilcox of H. C. Wilcox and Company. Their first products were britannia hollowares. Britannia is a silvery metal alloy of tin, antimony, and copper. By 1855, the company also produced plated-silver holloware and flatware. The Meriden Britannia Company was one of more than a dozen companies that merged to form the International Silver Company in 1898.

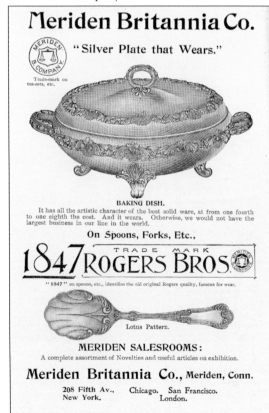

Electro-silver plating was first utilized, by the Rogers Brothers company, in 1947. Later associated with the Meriden Britannia Company and its successor the International Silver Company, the trademark was long used in their advertisements.

11

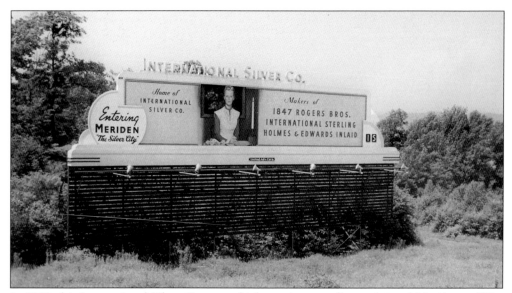

In 1946, this International Silver Company highway sign proudly proclaimed Meriden as "The Silver City." Formed in 1898, more than half a century later the firm adopted the name INSILCO. Hard hit by cheaper stainless steel flatware imports, the company diversified into other business ventures. Once the world's largest silver manufacturer, Meriden's largest employer operated multiple factory buildings. The company has been gone from the city since March 1981.

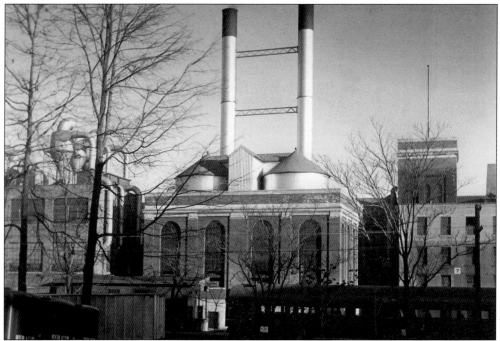

This is a view of International Silver Company's Factory E on State Street as it looked in 1953. During its long period of manufacturing in Meriden, the company made an array of silver products. In addition to an incredible variety of hollowware and flatware, all sorts of commemorative pieces were made, including swords, candelabras, medals, trophies, paperweights, chess sets, ornaments, and sculptures.

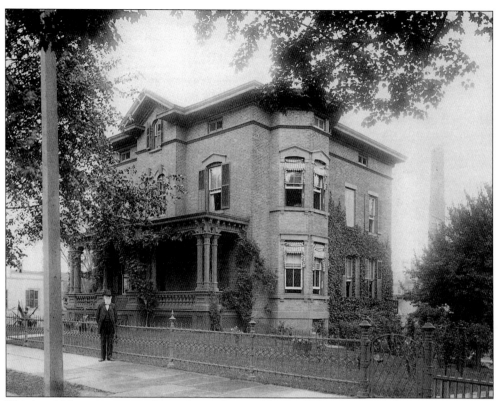

This late-19th-century view shows the residence of the Dodd family at 79 Colony Street. Samuel Dodd (1935–1906) was originally an officer in the silver-plated holloware business of Parker and Casper. When the business was absorbed into International Silver Company in 1898, Dodd served as the first president of International until his death in 1906. He was active in civic and business affairs and served in the state legislature.

Horace C. Wilcox was one of the founders and the president of the Meriden Britannia Company, from 1866 until his death. He was the first president of the Wilcox and White Organ Company and served on the board of directors of many other local firms. He was mayor of Meriden for two terms and in 1877 was elected to the Connecticut State Senate. Wilcox Technical High School is named for him.

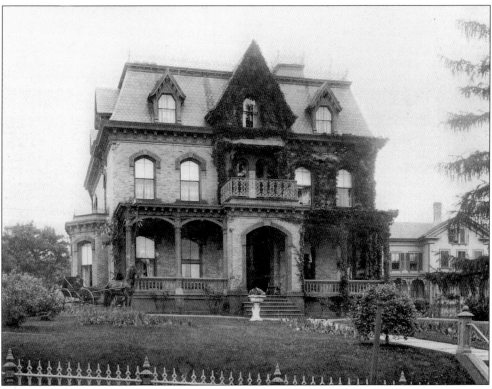

Isaac C. Lewis was president of Meriden Britannia Company for almost 14 years. He was also on the boards of several other Meriden businesses. The Meriden native served four terms in the Connecticut General Assembly, was on the city council, and was mayor of Meriden from 1870 to 1872. He was one of the earliest promoters of women's rights and suffrage.

Isaac C. Lewis built this Victorian Gothic home at 189 East Main Street in 1868. In 1950, the Polish Legion American Veterans bought the mansion for their fraternal hall. In 1989, it was used in one of the Meriden scenes for the movie *Jacknife*, starring Robert De Niro. From 1998 to 2006, a funeral home occupied the house. When the home closed in 2006, the building became available for lease.

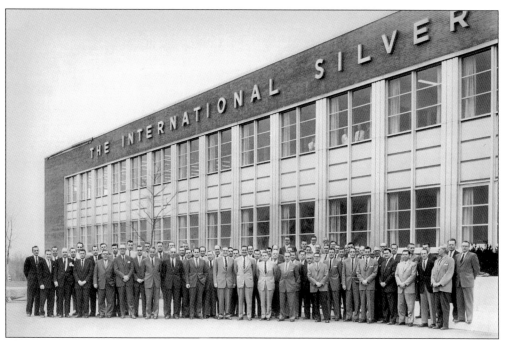

The International Silver Company erected a general administration building at 500 South Broad Street in the late 1950s. Meriden native John "Bub" Shaw (1910–2006), sales manager (first row, center), is shown in front with his team. Today Response Insurance Company and other commercial offices occupy the building.

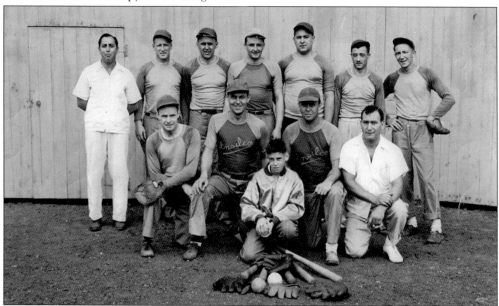

In 1944, the Insilco softball team posed with bat boy Ernie Thiesen Jr. in the first row; (second row, from left to right) Pat Clancy and John "Bub" Shaw; (third row, second from left) Ernie Thiesen, (third from left) Joe Kinel, and the rest are unidentified. The factory-sponsored team played at Insilco Field, which was located at the intersection of West Main Street and Centennial Avenue. (Courtesy of Jack Clancy.)

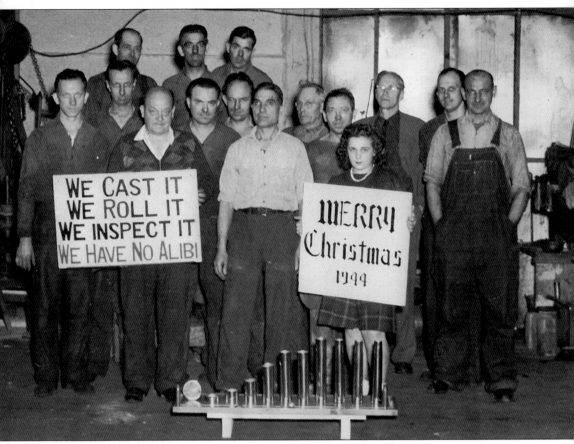

International Silver Company workers at Factory R paused for this Christmas photograph. During World War II, Meriden factories produced war materials around the clock in three shifts. Thousands of women who had never worked outside the home before were hired. Homes and factories were blackened with dark curtains at night to prevent potential air raids. Airplane-spotting stations were operated. Meat, sugar, and fuel were among the many rationed items. Life was difficult both overseas and on the home front. To recognize the city's important role in the effort, on March 8, 1944, the War Manpower Commission designated Meriden as "the Nation's Ideal War Community." Jimmy Durante and Glenn Miller were among the celebrity entertainers at the ceremony. A nonsectarian worship service was held at the town hall, with the "hope and prayer that the city would remain ideal in peace as well as war."

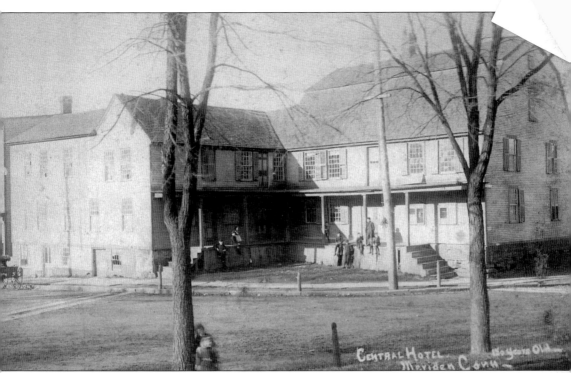

The Central Tavern was located on the northwest corner of Broad and East Main Streets. In the early 1700s, the building was erected as a farmhouse on land originally granted to William Jones. In 1739, Rev. Theophilus Hall purchased the farm. The next owner was Dr. Insign Hough, who by 1782 had converted the house into an inn known first as Hough's Tavern and later as the Central Hotel. His son Dr. Isaac I. Hough continued both his medical practice and the running of the hotel, which was a stopping point for stagecoaches. Isaac Hough became well known throughout Connecticut, both for his hospitality and his corpulent figure. In 1826, Partrick Lewis bought the tavern and opened a store there. After the railroad made stage travel obsolete, the center of town moved west. The tavern gradually declined and was razed about 1890. Other houses that stood on the lot were demolished. In 1931, a Standard Oil gas station was built on the site; it too was razed in 2000. A commemorative granite stone now marks the vacant plot.

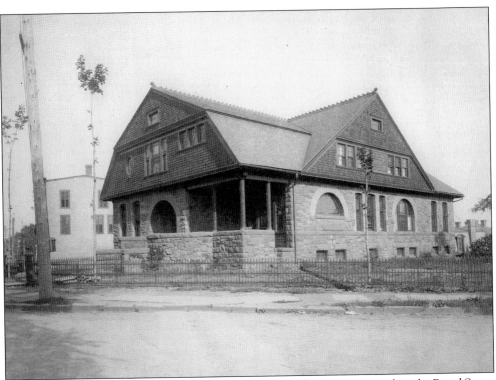

When the Central Tavern was demolished around 1890, this house was erected on the Broad Street site for William A. Kelsey. Starting in 1872, Kelsey Press had a successful business manufacturing small hand-printing presses. In 1894, the house was sold to Francis Atwater and in 1914, to Mayor Daniel J. Donovan. The gas station that was built on the lot in 1931 was razed in 2000.

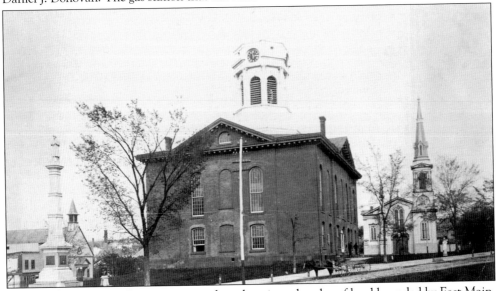

Meriden's first town hall was constructed on the triangular plot of land bounded by East Main, Liberty, and Norwood Streets. It was dedicated on December 5, 1855, and a week later the Reverend Henry Ward Beecher delivered the first lecture. The hall was known as the "town house." The first remodeling was in 1869, and the building served until 1889.

The clocks had not yet been installed in the town hall when this photograph was taken. A Grand Army of the Republic banner hangs over the doorway. More ornate and handsome than its predecessor, this complete remodeling of the first town hall included several additions and a clock tower. It only served from 1889 to 1904, when it was destroyed by fire. It cost $60,000 to build.

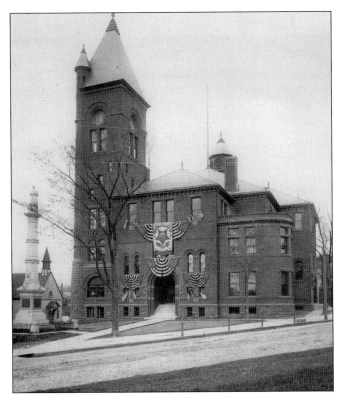

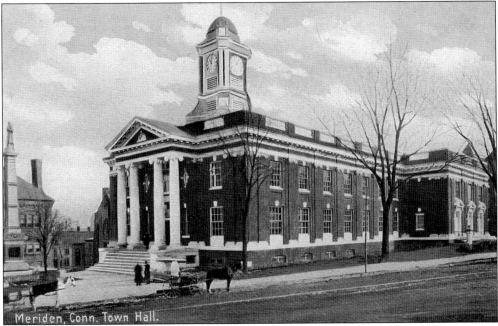

The present Georgian-Revival-style city hall shown in this early postcard view was finished in 1907, three years after its predecessor was destroyed by fire. The town appropriated $212,000 to build the facility on the same East Main Street site. The most recent renovation of the tower was completed in 2000. Portraits of all the mayors are featured in the lobby of the building.

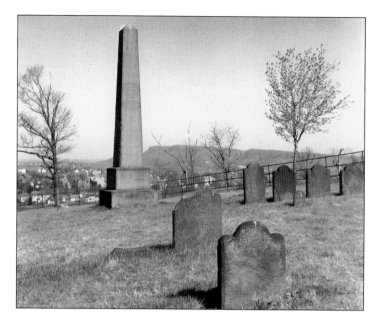

Meetinghouse Hill Burying Ground has had several names including Buckwheat Hill Cemetery and Indian Cemetery, although no Native Americans are buried there. Located at the end of Ann Street, it was Meriden's first burial ground, in use from 1727 to 1771. Winston Churchill's fourth great-grandfather Timothy Jerome is buried there. The obelisk in this 1950 photograph was erected in 1857 to record 29 burials, which no longer had markers.

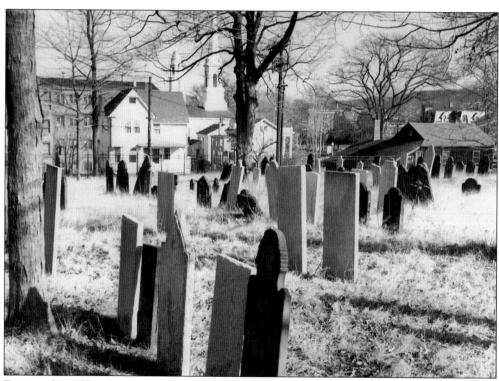

First used in 1771, the Broad Street Cemetery was the second burial ground in Meriden. It encompasses the whole city block fronting 402 Broad Street and is completely surrounded by an iron fence. Although some stones are missing or obliterated, it is still possible to read many of the 18th-century inscriptions. Revolutionary War veterans are commemorated with a plaque on the southeast side of the cemetery.

Two

AROUND TOWN

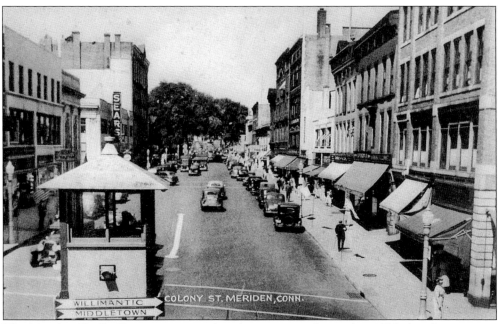

The Meriden Traffic Tower was erected in downtown in September 1925. A policeman was stationed inside the booth to direct traffic. When the tower was replaced by modern equipment in 1967, it languished in a city park for several decades. Because of its unique character, it was restored and reerected close to its original position in 1993 as part of the city's downtown revitalization effort.

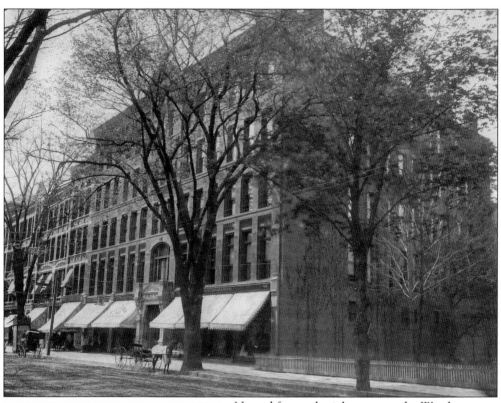

Named for a colonial governor, the Winthrop Hotel was built at 42 Colony Street in 1883. There were stores on the first floor with a broad stairway leading to the hotel upstairs. Of 104 rooms, 80 were sleeping chambers; the others were banquet rooms, food preparation areas, and so on. When it opened, the hotel was known as "the Pride of Meriden." The building perished in a spectacular fire on February 1, 1965.

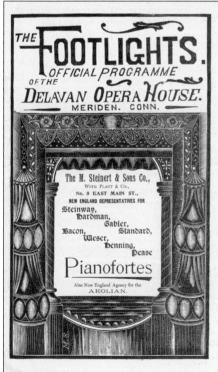

THE FOOTLIGHTS.
OFFICIAL PROGRAMME
OF THE
DELAVAN OPERA HOUSE.
MERIDEN. CONN.

The M. Steinert & Sons Co.,
WITH PLAUT & CO.,
No. 8 EAST MAIN ST.,
NEW ENGLAND REPRESENTATIVES FOR
Steinway,
Hardman,
Gabler,
Bacon, Standard,
Weser,
Henning,
Pease
Pianofortes
Also New England Agency for the
AEOLIAN.

Before the days of moving pictures, the Delavan Opera House was Meriden's premier playhouse. From its opening in a former church in 1879 until it burned down in 1906, the Church Street theater showcased leading stars. Minstrel shows, plays, opera, and vaudeville were all popular attractions. The program shown here is dated May 12, 1896, when the Frank Daniels' Comic Opera Company presented *The Wizard of the Nile*.

This 1953 view of Pratt Street shows the Hotel Petrose, operated by Peter Petruzelo from 1944 to 1964. Previously known as the Charter Hotel, Hotel Matis, and Hotel Meriden, it was within walking distance of the railroad station. In 1947, the Petrose claimed to be the first public building in Meriden to install a television. Ground floor stores included Sklar's, Silver's Smoke Shop, Petruzelo Insurance, and the Far East Restaurant.

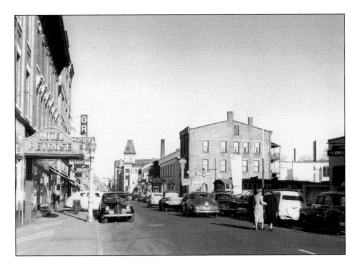

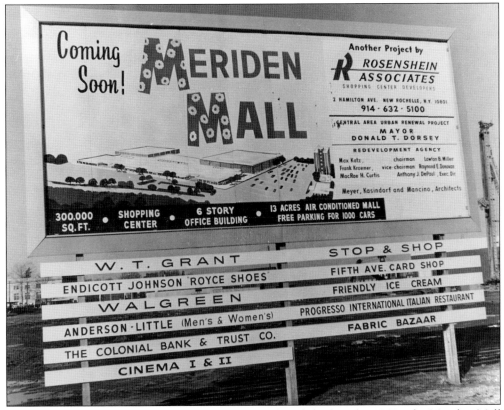

After the west side buildings on Pratt Street were demolished in the 1960s, the Meriden Mall shopping center occupied almost the whole block. Renamed the Meriden Hub in 1981, it in turn was razed in 2007. Redevelopment is still in the planning stage for the currently vacant 15-acre parcel. (Courtesy of Allen Weathers.)

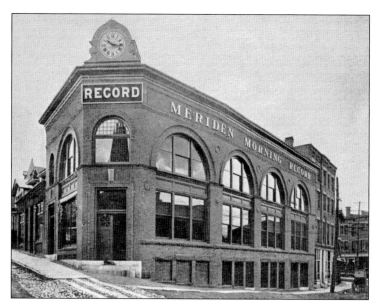

The Meriden Record Building was erected in 1905. Both the *Morning Record* and the afternoon *Meriden Journal* were begun in the 19th century. They were separately owned and operated until 1949, when the *Record* bought the *Journal*. Two editions per day were continued up until 1977 when the name changed to the *Meriden Record-Journal*, and the morning paper became standard.

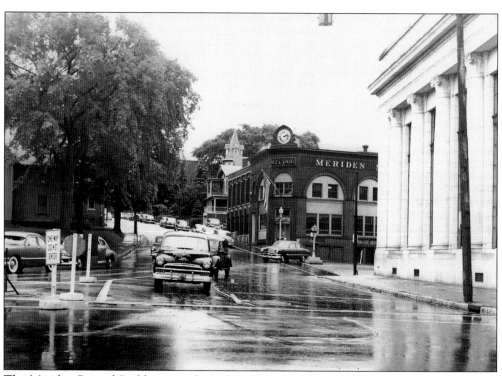

The Meriden Record Building as it looked in 1953. The Crown Street structure was further modernized with mosaic work in 1967. Today it has a digital electronic clock and thermometer. The *Record* is a privately owned community newspaper that was started in 1867 as the *Meriden Weekly Visitor*. It has been the most enduring of the city newspapers. The first Sunday edition was published in 1984.

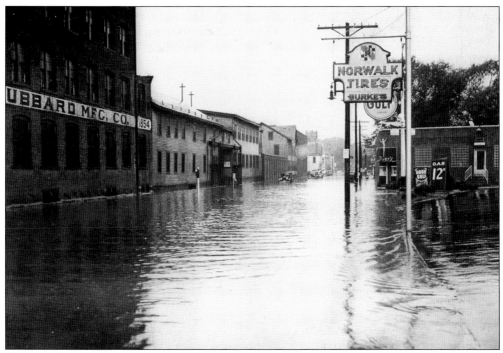

The great hurricane of 1938 caused widespread destruction throughout New England. With some Meriden streams 9 feet above normal, the late-September storm caused flooding, electrical outages, downed trees, and crushed cars. People were advised to boil their water and to use chlorine in flooded cellars. WPA workers helped with the massive clean-up. This after shot was taken on Hanover Street near the intersection of Grove Street.

Standing evening watch over Broad Street in the 1970s is the *Hiker* statue designed by Massachusetts sculptor Theo Alice Ruggles Kitson (1871–1931). She created over 50 versions of the statue commemorating the soldiers who fought in the Spanish-American War. Originally dedicated in 1941, Meriden's statue was knocked to the ground by a wayward car in 1976. It was soon restored and replaced. (Copyright Ernie Larsen.)

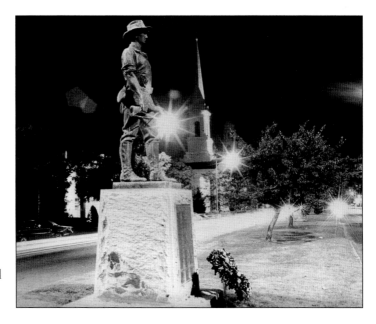

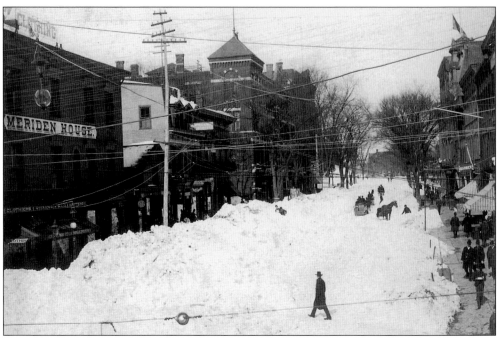

In mid-March 1888, Meriden and most of the Northeast United States was paralyzed by one of the most severe blizzards on record. The storm lasted for three days with heavy snow and high wind. This photograph is labeled "the Great Snow Blockade March 12, 1888." It was taken by Green Photography Studio of Meriden and depicts Colony Street looking north.

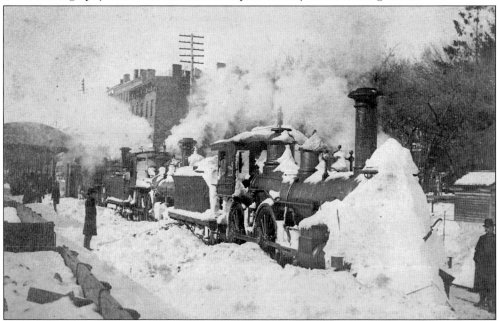

In another photograph taken after the blizzard of mid-March 1888, a train is visible at the railroad station. Trains could not get through the drifts, which were up to 20 feet in some areas. The storm was unexpected, and people were not prepared. Business came to a halt, and it took days to dig out.

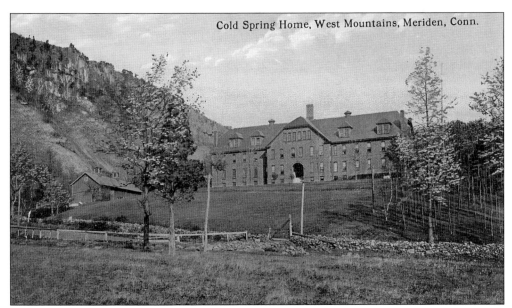

Cold Spring Home, West Mountains, Meriden, Conn.

In 1884, the Cold Spring poorhouse for the care of the elderly and infirm was constructed on the parcel of land known as Undercliff, off Chamberlain Highway. The brick building pictured here replaced the original home early in the 20th century. In 1968, the land and the outmoded building were sold to the State of Connecticut. Vacant for a number of years, the structure was destroyed by arson in 1992.

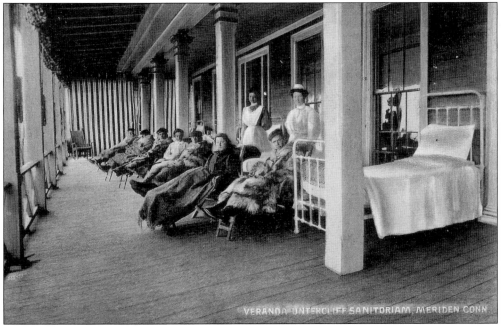

VERANDA UNTERCLIFF SANITORIAM MERIDEN CONN

A state sanatorium for the treatment of tuberculosis was operated at Undercliff, off Chamberlain Highway from 1910 to 1954. The property later had various other uses including a rehabilitation facility and a mental hospital. The State of Connecticut still owns the large acreage and buildings; some are vacant, and other buildings are used by the Connecticut Department of Developmental Services. This is a c. 1913 postcard view. (Courtesy of Allen Weathers.)

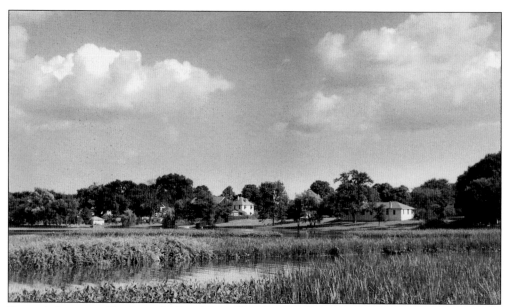

Formerly known as Hanover, the South Meriden section of town had also been called Falls Plain, due to the rapids in the Quinnipiac River. The name Hanover persists in street, school, and business names, but residents still call it "the Village." Photographed here in 1947, it was still a largely rural area. The exception was the Meriden Cutlery Company, established in 1853 and in business for more than 70 years.

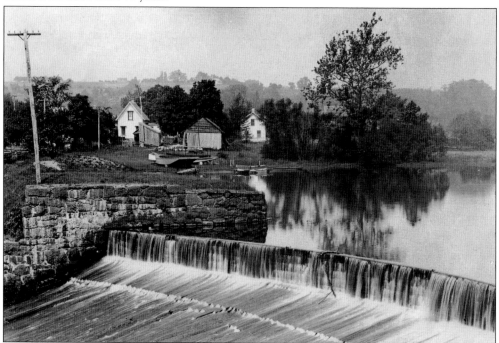

When the Meriden Cutlery Company built a dam at this site in South Meriden to produce waterpower for their factory, it resulted in the creation of Hanover Pond. Today only a few foundation stones are left to mark the location of the immense factory that employed up to 200 people who produced many types of knives and other cutlery. This view is from around 1900.

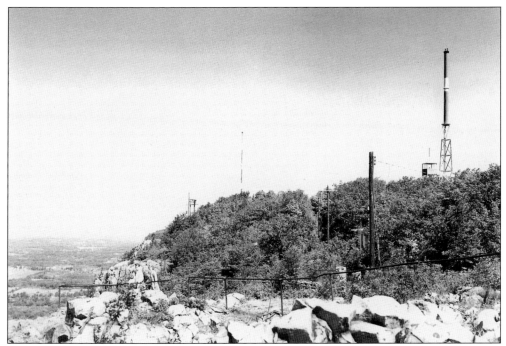

Radio towers have been a feature on West Peak since a tower was built in 1936. One of the first experimental FM radio station broadcasts was transmitted from the mountain on October 2, 1939. This view was taken in 1952.

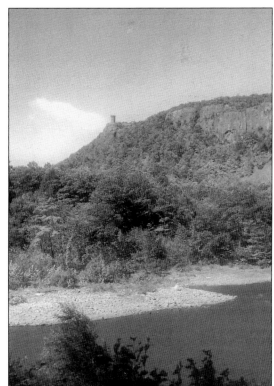

Merimere Reservoir is in the foreground of this 1948 photograph illustrating a typical traprock ridge of Meriden's Hanging Hills. The cliffs were created by volcanic activity millions of years ago. Hikers are entertained by a persistent legend of a black dog that delights viewers upon their first encounter. The second encounter provides a warning, and the third sighting means one will not return from the mountain alive.

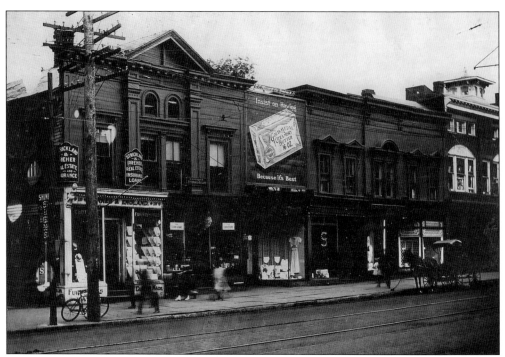

Maxwell Company of Trenton, New Jersey, took this photograph around 1914 to highlight their advertising sign for butter. Emerson A. Merriman—attorney, Barnes and England men's furnishings, Strickland and Dreher—real estate and insurance, Singer Sewing Machine Company, and a clock store were some of the tenants at 18 to 24 West Main Street.

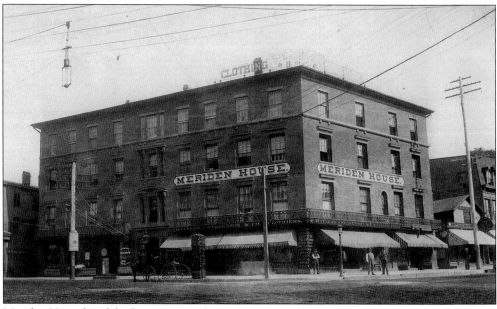

Meriden House hotel, built in 1853, was located at the northwest corner of Colony and West Main Streets. When this late-century view was taken, the first floor featured a pharmacy, a Western Union telegraph office, a clothier, and a jeweler. The hotel was razed after World War I, and in its place the Derecktor building was constructed.

Three

BUSINESS AND INDUSTRY

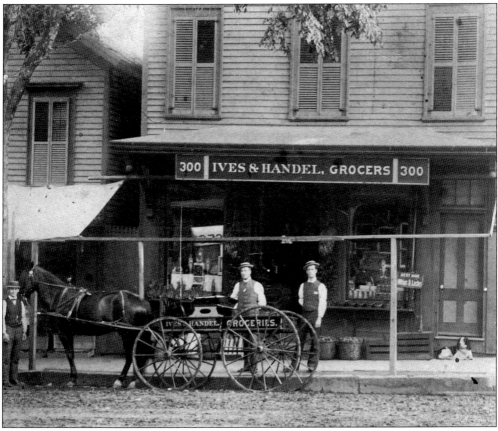

George W. Ives and F. W. Handel operated this grocery store at 300 East Main Street in the mid-1880s. Earlier it was called Ives and Cook. Around 1900, it was run by Edward J. Stoddard, dealer in choice groceries who had "goods delivered to any part of the city free of charge." By 1901, Frederick L. Yale, grocer, became the longtime occupant. The building currently houses Uptown Pizza.

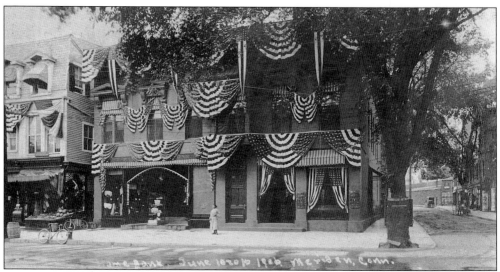

Originally chartered as the Home Bank of West Meriden in 1854, the bank is pictured here decorated for the 1906 centennial celebration. When Connecticut governor Abiram Chamberlain served as Home Bank president from 1881 to 1911, he and his family lived on the second floor of this brick building at the corner of Colony and Church Streets. It was moved around the corner in 1922, and a larger office was erected.

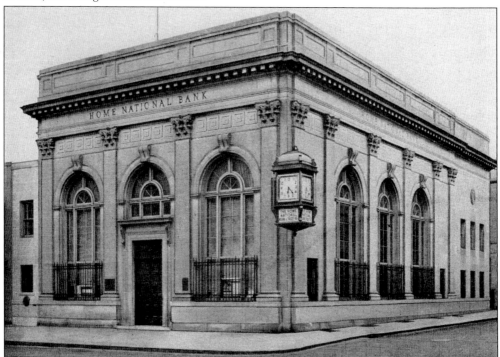

The Home Bank and Trust Company was acquired by Shawmut Corporation of Boston in 1986; by 1988, the word "home" was gone from its title, as it became absorbed into the Connecticut National Bank. The limestone building at 16 Colony Street was designed by the New York firm of McKim, Mead, and White. After a period of vacancy and various uses, it is currently occupied by a nightclub.

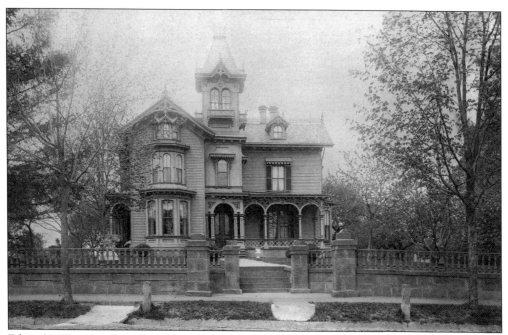

Edward Miller, founder of the Edward Miller Company, erected this mansion in the 1860s at 360 Broad Street. When it was destroyed by fire in February 1934, Miller's niece Arline Kendrick DeGraff and her husband were the householders, but they were away at the time of the fire. This photograph was taken around 1892.

Founded by Edward Miller in 1844, Miller Company remains the city's oldest firm. They first produced candlesticks and lamps; varied products and a metal rolling mill were added later. In 1965, architect Philip Johnson designed a distinctive modern addition to the Pratt Street factory. The lighting division was sold in 1985. In 2000, the company was purchased by a division of the Diehl Corporation, a German manufacturer, who has continued production of copper-base alloys.

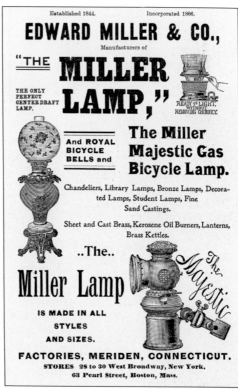

Established 1844. Incorporated 1866.

EDWARD MILLER & CO.,

Manufacturers of

"THE **MILLER LAMP,"**

THE ONLY PERFECT CENTER DRAFT LAMP.

READY TO LIGHT, WITHOUT REMOVING CHIMNEY.

And ROYAL BICYCLE BELLS and

The Miller Majestic Gas Bicycle Lamp.

Chandeliers, Library Lamps, Bronze Lamps, Decorated Lamps, Student Lamps, Fine Sand Castings.

Sheet and Cast Brass, Kerosene Oil Burners, Lanterns, Brass Kettles.

..The..

Miller Lamp

IS MADE IN ALL STYLES AND SIZES.

The Majestic

FACTORIES, MERIDEN, CONNECTICUT.
STORES 28 to 30 West Broadway, New York.
63 Pearl Street, Boston, Mass.

33

Charles Parker (1809–1902) founded the Charles Parker Company, which produced coffee mills and numerous other items including printing presses, vises, spoons, and clocks. In 1868, he and his sons founded the Parker Brothers Gun Company, which made the "Old Reliable" shotgun. The firm continued until being bought out by Remington Arms in 1934. In addition to running multiple factories, Parker served as the first mayor in 1867.

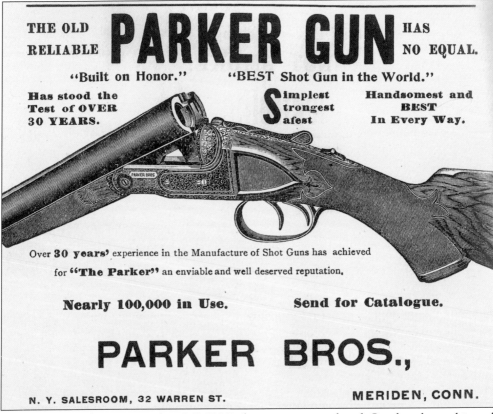

THE OLD RELIABLE **PARKER GUN** HAS NO EQUAL.

"Built on Honor." "BEST Shot Gun in the World."

Has stood the Test of OVER 30 YEARS.

Simplest **S**trongest **S**afest

Handsomest and BEST In Every Way.

Over **30 years'** experience in the Manufacture of Shot Guns has achieved for **"The Parker"** an enviable and well deserved reputation.

Nearly 100,000 in Use. Send for Catalogue.

PARKER BROS.,

N. Y. SALESROOM, 32 WARREN ST. MERIDEN, CONN.

Between 1866 and 1942, more than 240,000 Parker guns were produced. Good workmanship and slogans like "Best Shot Gun in the World" helped marketing, with advertisements like this from 1902. Parker manufactured a shotgun that had been destined for Czar Nicholas II of Russia, but World War I broke out just as the gun was finished, and it never reached its destination. In 2007, it sold at auction for $287,500.

The Napier Company started as E. A. Bliss Company in 1875. On this 1950s postcard, it advertised "the finest in fashion jewelry, boutique items, and unusual gifts." They had a factory outlet store that delighted bargain hunters, and generations of Meriden citizens enjoyed wearing Napier jewelry. The Meriden plant closed operations in 1999.

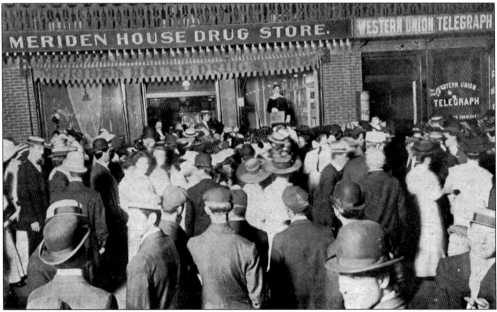

Charles H. Pinks (1858–1937) ran a drugstore from 1886 until the 1930s, first at 21 West Main Street, then in the Meriden House as pictured here. His third store was on Colony Street, and lastly he was located at 2 East Main Street in the Hall and Lewis Building. The crowd in this 1908 advertising postcard is watching the "automatic boy" in the window. (Courtesy of Allen Weathers.)

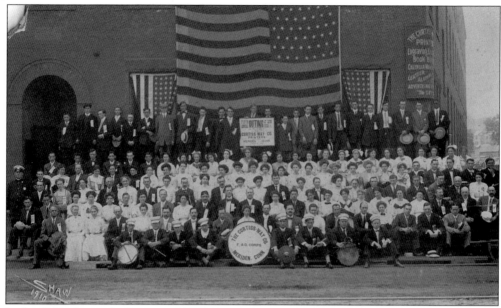

In the 1880s, James A. Curtiss and William H. Way started the printing firm called Curtiss Way. Employees are pictured here at their 1910 annual outing. The company printed the *Old Farmer's Almanac* for over 30 years. By 1950, a second plant ran three shifts producing comic book covers. Later owned by Eastern Color Printing, they were purchased in 1960 by Hughes Company and became the Domonel Press. Both plants closed by 1968.

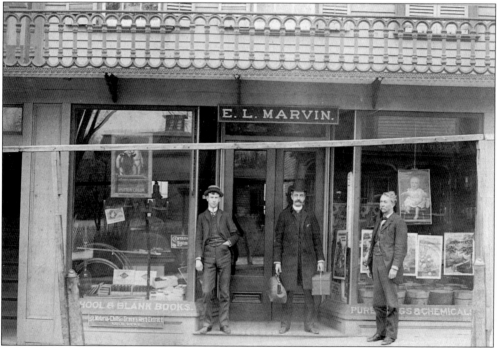

In the 19th century, E. L. Marvin had one of the first drugstores in town. Located at 298 East Main Street near the corner of Center Street, by 1892, the name had changed to Marvin and Barber. It later became Lynch's Drug Store.

P. J. HANDEL,

ARTISTIC

LAMP GLOBES

Richly Decorated Lamp Shades,

Salts, Peppers and other Novelties.

Office and Salesroom,

381 East Main St., beyond Broad St.,

MERIDEN, CONN.

From the late 1800s until the Depression era, the Philip J. Handel Company made exquisite lamps, art glass, and reverse-painted glass shades that continue to be sought by collectors. The factory at 381 East Main Street employed multiple artists, designers, and craftsmen, including artist Henry A. Bedigie, to produce their brilliant hand-painted fadeless lamp shades.

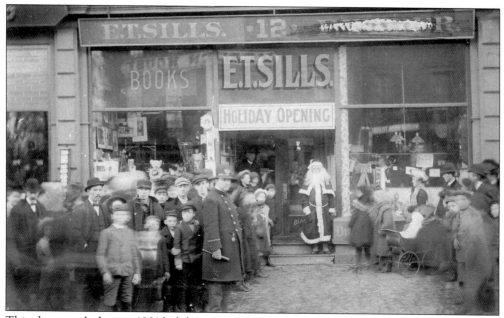

This photograph shows a 1901 holiday view of the Elias T. Sills bookstore at 12 West Main Street. John F. Randall is dressed as Santa Claus. The popular store carried sundry items in addition to books. Sills had several successive business locations, starting on Colony Street in 1883 and continued by his wife at 18 State Street after his death in 1922. (Courtesy of Allen Weathers.)

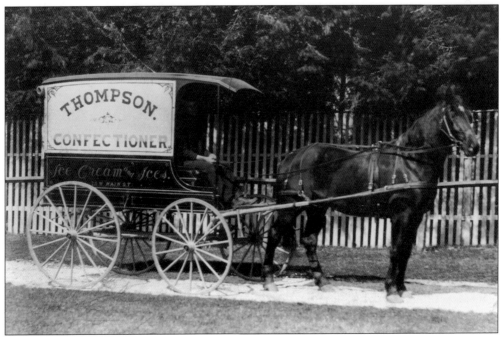

In 1879, confectioner William H. Thompson (1855–1929) opened his first store at 75 West Main Street. Relocating first to Colony Street and then to the corner of Church Street and High School Avenue, the long-lived Thompson Candy Company continues today on South Vine Street. For those with a sweet tooth, no Meriden visit is complete without a trip to the outlet store where chocolate and seasonal candy specialties abound.

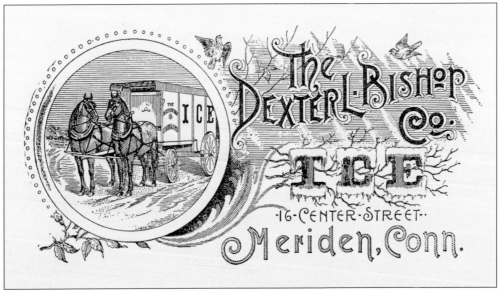

Before electric refrigeration, the Dexter L. Bishop Company was the largest of several Meriden companies that provided ice to chill food. Ice was harvested from various town lakes, stored, and then delivered to homes. It was transported by horse and wagon such as the one pictured in this 1899 advertisement. The Foster Lake ice house had a capacity of 8,500 tons. The lake is now known as Bishops Pond.

38

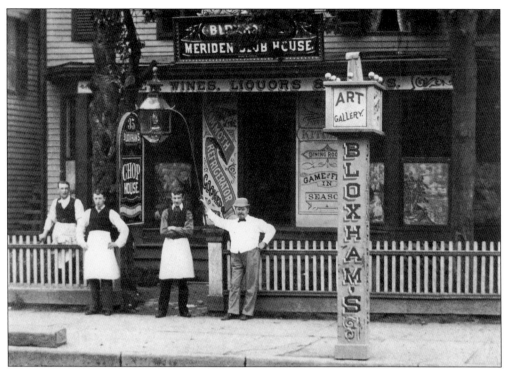

Harry Bloxham was a silversmith for Meriden Britannia until he took over this restaurant club house at 35–37 West Main Street in 1870. Game and fish were served in season, and chops were cooked to order. The business remained in the same location until 1883, when Bloxham opened a new hotel on State Street opposite the passenger depot.

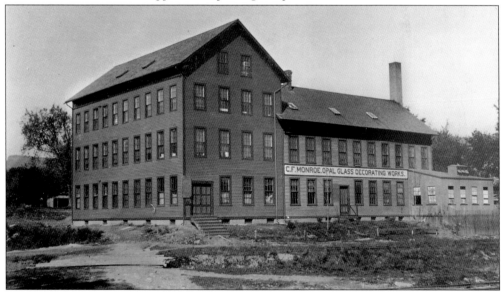

Charles F. Monroe started his career as a decorator for the Meriden Flint Glass Company. In 1880, he opened his own shop, and by 1886, the C. F. Monroe Opal Glass Decorating Works was located in this building at West Main Street and Capitol Avenue. The company closed in 1916. Today the decorated Monroe glassware pieces that were produced in the city are desirable antiques.

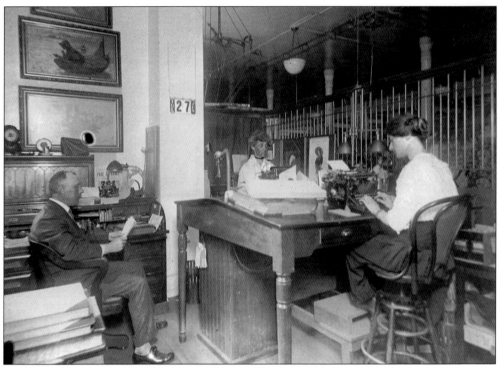

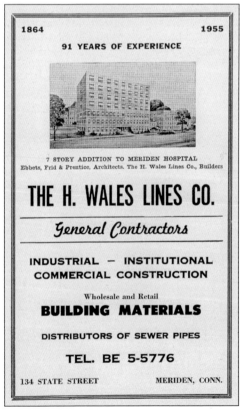

The Ives, Upham, and Rand Company, better known as Upham's department store, was established in 1836 and was one of the oldest department stores in New England. It was located in the Winthrop Hotel Building on Colony Street. This photograph from the early 1900s depicts how it looked behind the scenes. Notice the early typewriter. (Courtesy of Allen Weathers.)

Started as the Perkins and Lines Company in 1864, the H. Wales Lines Company was the city's premier construction firm for more than 100 years. Known as the "Company that Built Meriden," they constructed thousands of attractive residences, factories, and churches in dozens of states. When the company dissolved in 1983, their headquarters at 134 State Street were converted to offices where the Community Health Center is now located.

In 1854, the Bradley and Hubbard Company was founded by Nathaniel Bradley and Walter Hubbard. After the 1940s, the firm became a division of the Charles Parker Company. The last Bradley and Hubbard lamp was made in the early 1950s. Over the long course of the company's existence they also manufactured clocks, railings, vases, tables, mirror frames, smoking accessories, bronze statuary, book ends, and other useful and decorative articles.

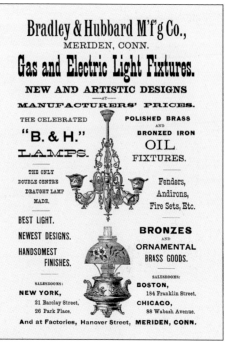

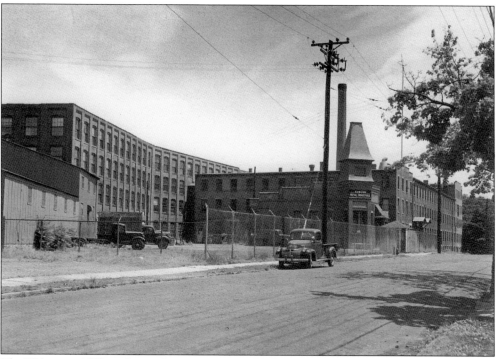

The Wilcox and White Organ Company was established on Cambridge Street in 1877 by Horace C. Wilcox and Henry Kirk White and his sons. The Whites invented the Symphony, a self-playing organ operated with perforated paper rolls. Later devices included the Angelus, which played a piano mechanically, and the Artrio-Angelus, which recreated variations of the original performers. The advent of radio contributed to the demise of the company in 1922.

41

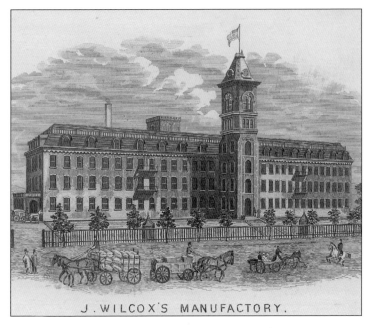

J. WILCOX'S MANUFACTORY.

In 1848, Jedediah Wilcox operated a carpet-bag factory on Pratt Street. Belts, corsets, and hoop skirts were soon added. After the building was destroyed by fire in 1865, Wilcox erected this woolen mill across the street. Also known as the Balmoral Skirt Factory, the plant employed many workers. In the 1920s, the site was acquired by the New Departure Division of General Motors. It currently houses various small businesses.

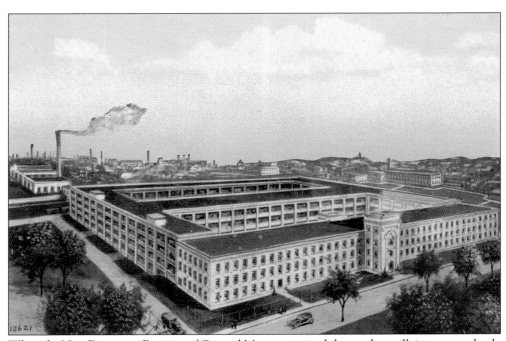

When the New Departure Division of General Motors acquired the woolen mill, it was completely renovated and enlarged. During World War II, the company operated three shifts, employing more than 8,000 workers to manufacture ball bearings and other precision products. It received multiple awards from the government for its efforts. The building still resembles this early postcard view, although it is now occupied by individual small businesses.

Jedediah Wilcox built this $125,000 mansion at 816 Broad Street in 1868. By 1874, the bankruptcy of Wilcox's business forced a sale to Mayor Charles Parker. The final occupant was the Beechwood Manor Convalescent Home. After their closure, a citywide effort to save the house failed. When it was razed in 1968, the parlor was purchased by the Metropolitan Museum of Art in New York and is on display there.

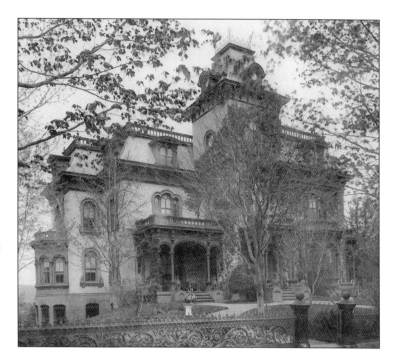

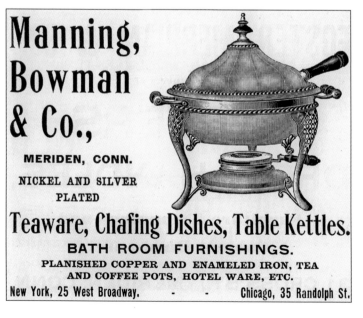

Started in 1832, Manning Bowman and Company first made pots and pans and other metal goods. They moved to Meriden in 1872. By 1915, they made small appliances such as toasters. Later items included bread mixers, coffee percolators, waffle irons, electric clocks, cigar lighters, and novelties. Their slogan was "M. B. Means Best." After World War II, all Meriden operations were closed, and the company became a subsidiary of McGraw-Edison Company.

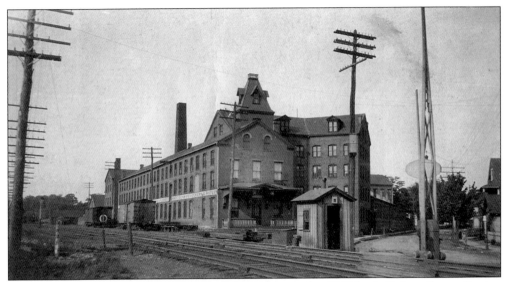

The factory of the Meriden Firearms Company was located at 508 North Colony Street. During the height of their production, they turned out 200 guns per day. A. J. Aubrey was the general manager, and F. A. Stephani was the treasurer of the firm. The stock was held by Sears, Roebuck, and Company.

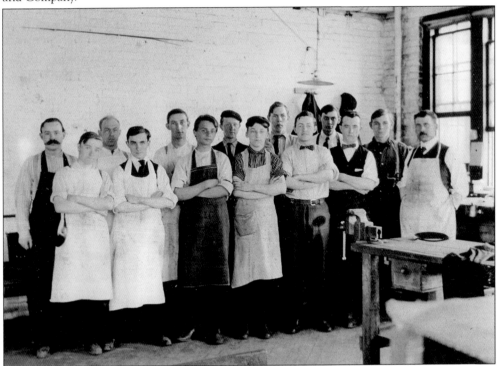

The employees of the Meriden Firearms Company engraving department pose in their workroom in 1907. The only employee identified is John L. Perkins (fourth from right). Connecticut native Albert J. Aubrey was president and general manager of the firm that made shotguns, rifles, and revolvers from 1905 to 1916. The company was owned by the Sears, Roebuck, and Company, and the guns were marketed through their catalog.

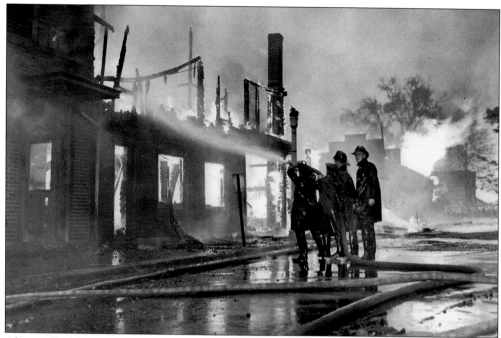

Almost all of the Meriden Lumber Company property on State Street was destroyed in a disastrous fire on October 5, 1954. The fire threatened neighboring buildings and was so hot their windows cracked. Firefighters from surrounding towns assisted in extinguishing the blaze. Losses were estimated at $500,000. This photograph by Allen E. Myers appeared on the front page of the *Meriden Record* the following morning.

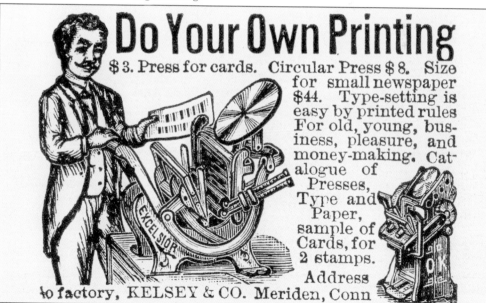

Do Your Own Printing

$ 3. Press for cards. Circular Press $ 8. Size for small newspaper $44. Type-setting is easy by printed rules For old, young, business, pleasure, and money-making. Catalogue of Presses, Type and Paper, sample of Cards, for 2 stamps. Address to factory, KELSEY & CO. Meriden, Conn

William A. Kelsey started producing small printing presses in 1872. The Excelsior table model, depicted in this 1889 advertisement, proved very popular and was made in several sizes. The company eventually closed, but the presses are so durable that serviceable models can still be purchased from antique dealers or online auctions for many times the original price.

On August 7, 1949, the marquee of the new Meriden Theater read, "Gala opening Aug 10, James Stewart in *Stratton Story*, Plan now to be here, Park Free." The movie theater was located on South Broad Street near the Wallingford town line. Later called the Meriden Twin cinema, it was demolished around 1988 to make way for the Townline Square shopping center.

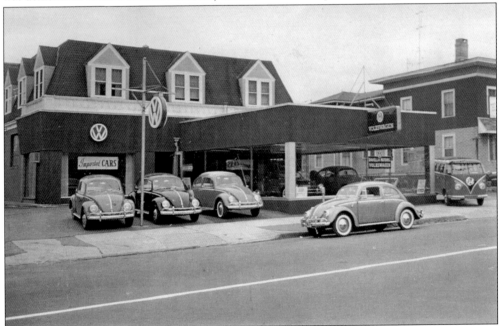

Frank E. Davella (1911–1996) opened Davella Motors on West Main Street in 1951. One of the oldest Volkswagen dealers in the country, they sold 3 of the 368 beetles retailed that year in the United States. The business closed on December 31, 1997. This postcard view was taken around 1959. (Courtesy of Allen Weathers.)

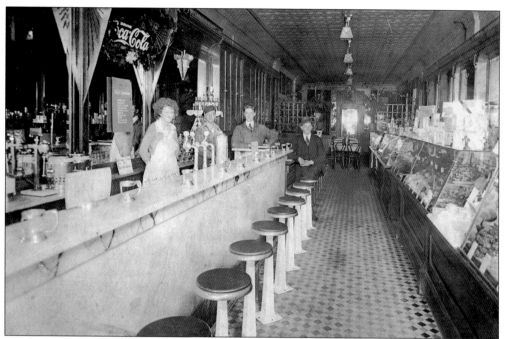

In 1889, Julius Katt founded Katt's confectionery store in the Mag block at 46 West Main Street. When his sons, Alfred and Clarence, took over the long-lived business, it was known as Katt Brothers. The favorite ice cream and candy store for generations of Meriden families was in business in the same location, until it finally closed in 1970.

Pictured here in 1949, Ragozzino's small grocery store was located at 2 Ames Avenue. In 1952, owners Joe and Anna Ragozzino starting making their own spaghetti sauce from a family recipe. Later a full-scale facility was built to produce the sauce. Today the family and female-owned business ships food products all over the country.

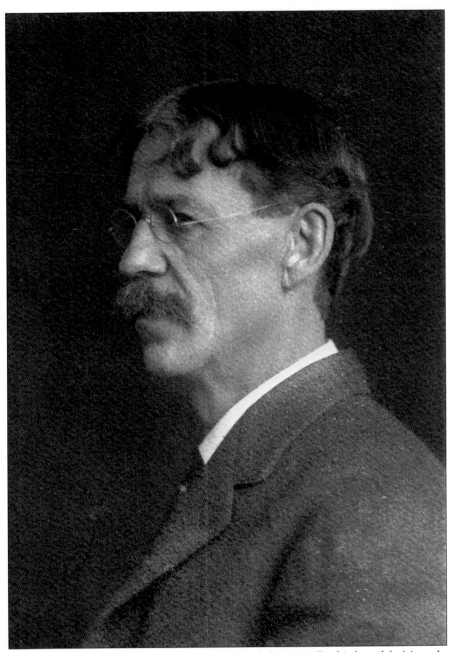

Pictured here is the Reverend Dr. Frank Channing Haddock (1853–1915), of Auburndale, Massachusetts, the author who inspired Albert L. Pelton to start publishing self-help books. Pelton (1881–1970) was originally an advertising solicitor and newspaper advertisement copywriter for the *Meriden Morning Record*. After reading and rereading Haddock's *Power of the Will*, he published it and sold more than 500,000 copies by mail order. Pelton became a millionaire by publishing self-improvement books from his company in Meriden, under the imprints of Ralston University Press and Ralston Press. In addition to Haddock, the firm published authors such as Napoleon Hill and Edmond Shaftsbury. In 1920, Pelton published the only book he wrote himself, a tiny volume entitled *The Creed of the Conquering Chief, as expounded by the inspired orator, an experiment in psychology.*

Four

PEOPLE AND ORGANIZATIONS

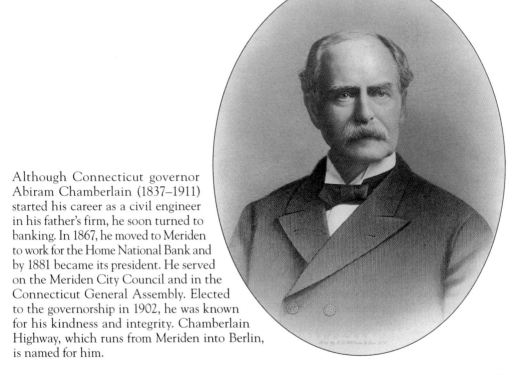

Although Connecticut governor Abiram Chamberlain (1837–1911) started his career as a civil engineer in his father's firm, he soon turned to banking. In 1867, he moved to Meriden to work for the Home National Bank and by 1881 became its president. He served on the Meriden City Council and in the Connecticut General Assembly. Elected to the governorship in 1902, he was known for his kindness and integrity. Chamberlain Highway, which runs from Meriden into Berlin, is named for him.

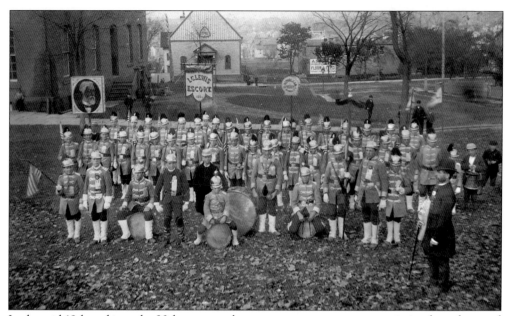

In the mid-19th and into the 20th century, there were many temperance societies that advocated abstinence from alcohol. The banner pictured here reads, "Isaac C. Lewis Escort" and is presumed to be part of the 14th division of the Sons of Temperance society. By the mid-1880s, Meriden counted seven different temperance associations.

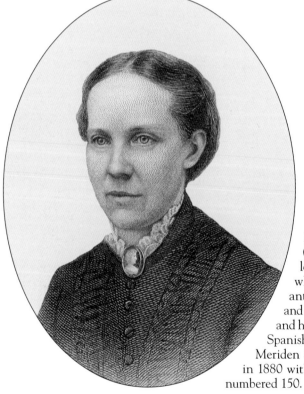

Meriden native Emily J. Leonard (1837–1884) was a teacher, scientist, lecturer, scholar, linguist, and author who promoted women's rights and antislavery causes. Well-read in Greek and Latin, she also spoke French, German, and had a reading knowledge of Italian and Spanish. She was one of the organizers of the Meriden Scientific Association, which began in 1880 with 11 members and by its ninth year numbered 150.

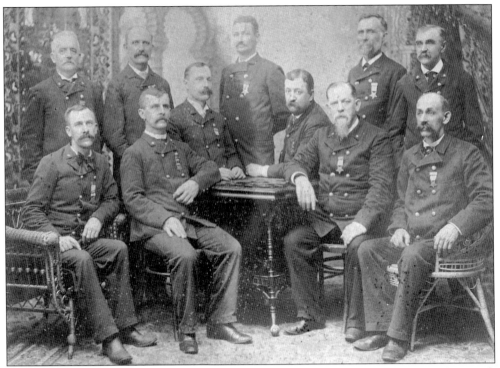

The officers of the Merriam Post, No. 8, Grand Army of the Republic pose for the camera. The photograph is labeled only with last names. Pictured from left to right are (seated) MacCall, Harvey, Blakesly, F. Smith, Sloane, and Clark; (standing) Fairchild, Kilbourne, Kelly, Breckenridge, and Potts.

The Grand Army of the Republic was a national fraternal organization composed of men who had fought for the Union during the Civil War. They were instrumental in helping establish Decoration Day, which later evolved to become Memorial Day. Meriden's GAR, Merriam Post No. 8 is posed here in front of the City Mission Building at 69 East Main Street on August 11, 1890. Most of the men sport mustaches.

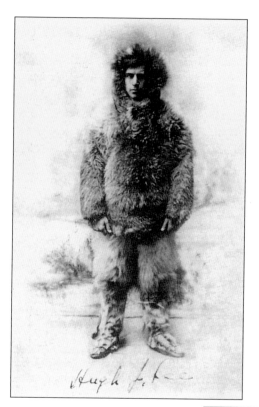

Hugh Johnson Lee (1871–1944), was an explorer, editor, and author. He accompanied Lt. Robert Peary, discoverer of the North Pole, on several of his Arctic expeditions. He was deputy U.S. marshal in Alaska for 12 years. In 1897, he and his bride, Florence Leonard, spent their honeymoon in the Arctic Circle. For the last 26 years of his life, he was an editor at the *Meriden Record* newspaper.

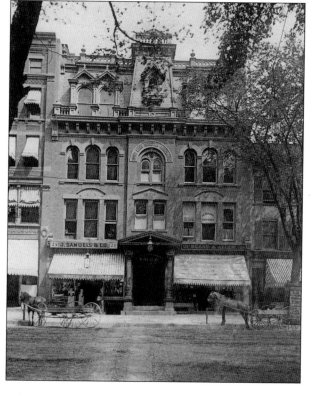

The YMCA of Meriden started in 1866. This building on Colony Street was dedicated in 1877. A barber occupied the basement, the first floor housed a store, the second floor contained a library and lecture rooms, and the third had a hall. The YMCA moved to West Main Street in 1920. Since 1996, the organization has been active in a new building at 110 West Main Street.

Although Meriden had a subscription library as early as 1796, it was not until a women's organization called the Thursday Morning Club raised money that a public library came into being. In 1903, club member Augusta Munson Curtis (1833–1914) provided funds to construct the Curtis Memorial Library on East Main Street. The building was dedicated in memory of her husband, George Redfield Curtis, and her daughter, Agnes Deshon Curtis Squire.

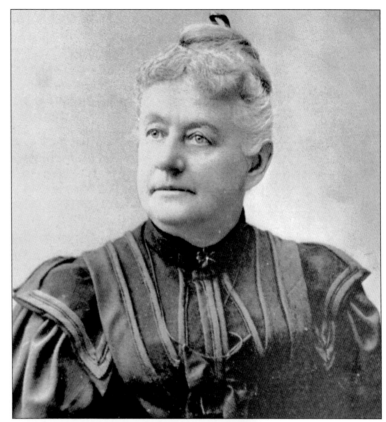

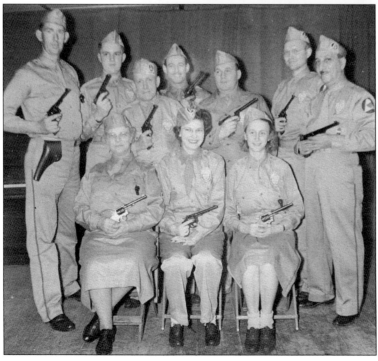

This photograph of the Meriden Auxiliary Police Pistol Team was taken in May 1943. From left to right are (first row) Corp. Caroline Clark, Helen Carey, and Evelyn Straub; (second row) Mac Leon, Richard Nauman, Tom Davis, Frank Lombardo, Lt. Allen Kingsford, Sgt. Herb Straub, and Bill Tordo—instructor.

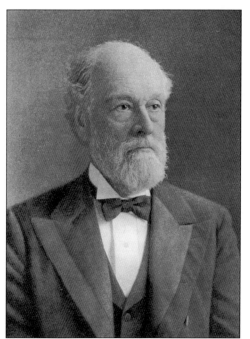

Orville H. Platt (1827–1905) was admitted to the bar in 1850, practicing law first in Pennsylvania then in Meriden. He served as a U.S. senator for 26 years and was chairman of the Committee on Patents. He is best known for the 1901 Platt Amendment, a rider to the Army Appropriation Act, which gave legislative authority for government activities in Cuba. A city high school is named for him.

Judge James Platt, the son of Sen. Orville Hitchcock Platt, inherited his father's former home at 130 Lincoln Street. In 1951, Judge Platt's widow, Harriet Ives Platt, bequeathed the house to the Meriden Girls Club in memory of her daughter Margery. The club, now Girls Inc., is headquartered there. They sponsor numerous programs to promote girls' growth and education, inspiring them to be "Strong, Smart and Bold!" This view is from 1952.

Industrialist and philanthropist Nathaniel L. Bradley (1829–1915), along with his partner Walther Hubbard, founded the Bradley and Hubbard Manufacturing Company in 1854. Bradley was also a stockholder and director in the first Meriden street railway company. He was a director of several banks and numerous other local businesses and educational institutions. Additionally he served as an alderman and acting mayor.

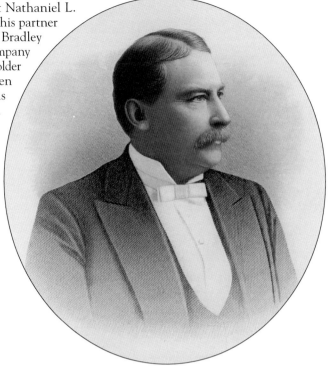

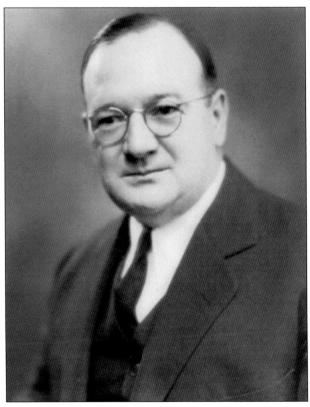

Francis T. Maloney (1894–1945) was a newspaper reporter, insurance agent, and mayor of Meriden (1930–1933) who became a U.S. representative (1933–1935). He was elected to the U.S. Senate in 1935, where he served until his death. During World War I, he was a seaman, 1st class in the U.S. Navy. One of the two public city high schools is named for him.

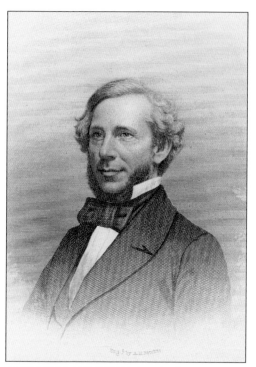

In 1849, George Perkins (1804–1856) compiled the first published history of Meriden. The Reverend Perkins was an abolitionist and active in the Underground Railroad. He graduated from Yale in 1824. He served as pastor at the American Presbyterian Church in Montreal for 10 years, 14 years at the First Congregational Church in Meriden, and 2 years at the First Congregational Church in Chicago.

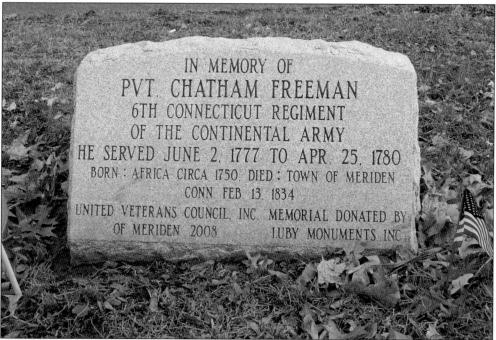

Chatham Freeman was born in Africa about 1750. He fought in the Revolutionary War from 1777 to 1780 in the 6th Connecticut Regiment. For that service, he was freed from slavery in 1782. He died in 1834. It is believed "Old Chat" is buried in an unmarked grave in the Broad Street Cemetery. To commemorate his life and service, this memorial was placed on the Broad Street median in 2008.

The Pleasant Street residence of Dr. Charles H. S. Davis is shown here as it appeared in the early 1890s. A lilac in bloom at the corner of the home denotes the spring season. Dr. Davis sits in his carriage as if he were ready to go on a house call. The house no longer stands.

Dr. Charles Henry Stanley Davis (1840–1917) was a physician, mayor, state senator, Egyptologist, linguist, school board member, Meriden treasurer, trustee for the Connecticut School for Boys, and author. He traveled widely. He was a 32nd-degree Mason and Shriner, a member of the Odd Fellows, the Knights of Pythias, the Elks, and a number of other societies, including 25 scientific archaeological, anthropological, literary, and historical societies. Davis wrote the 1870 *History of Wallingford*, which covers the early history of Meriden, "which was one of its parishes until 1806."

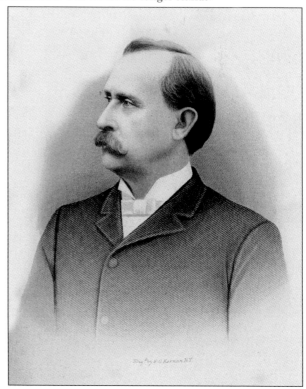

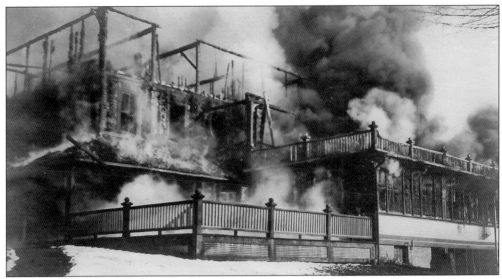

Horace C. Wilcox constructed the Highland Hotel in 1883. In 1909, it was remodeled and leased to the Meriden Golf Club. Although located in Westfield, the Highland Country Club was easily accessible by trolley and served as the center of Meriden social activities. After the building burned on November 24, 1914, a new clubhouse was erected. By the 1940s, the club was gone, and the land was reforested. (Courtesy of Allen Weathers.)

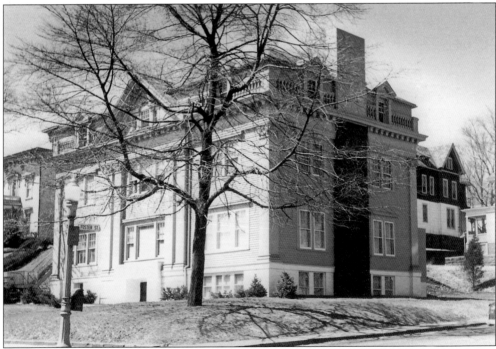

This photograph was taken in 1950 of 128 Colony Street, which was once home to an exclusive social organization called the Home Club. It its heyday, it had more than 300 members, many of whom were business and civic leaders. When the club closed in 1989, the building languished and went into foreclosure. Now in the hands of a private contractor, the 1890s structure is being renovated.

Rosa Ponselle seems to look down from the mantle on Robert J. Cyr (1921–2004) who was speaking at the Curtis Memorial Building during a three-day celebration tribute to Ponselle in October 1982. Cyr, retired Platt High School music teacher and music education director for the Meriden schools, was the first president of the Rosa Ponselle Fund, which was used from 1982 to 2009 "to improve the musical culture of Meriden."

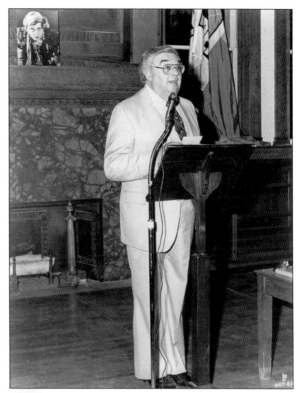

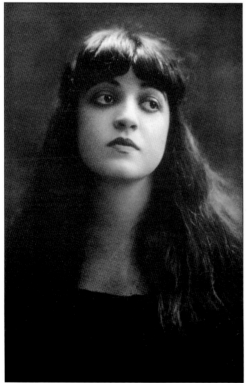

Meriden native Rosa Ponselle (1897–1981) grew up in the Italian neighborhood of Springdale Avenue. She and her sister Carmela began their singing careers in vaudeville. Discovered by Enrico Caruso in 1918, Rosa made her Metropolitan Opera debut opposite the famous tenor. She retired at the height of her career in 1937 but continued to be involved in the musical world by coaching and teaching from her villa near Baltimore.

The husband and wife team of James Kennedy and Maude Smith Kennedy toured on the vaudeville circuit for over 30 years. They entertained troops during both World Wars with their song and dance routines. After their retirement in 1943, they settled in Meriden. Maude died in 1946. Jimmy became the circulation director of the *Meriden Record* newspaper, a position he held until his death in 1961.

Baseball Hall of Fame pitcher Edward A. "Big Ed" Walsh (1881–1959), who played major league baseball for the Chicago White Sox and the Boston Braves, holds a career earned run average of 1.82. After he retired from sports, he worked for the city as supervisor of the Broad Brook Reservoir. His name is honored in the city's Ed Walsh Little League. (Courtesy of Allen Weathers.)

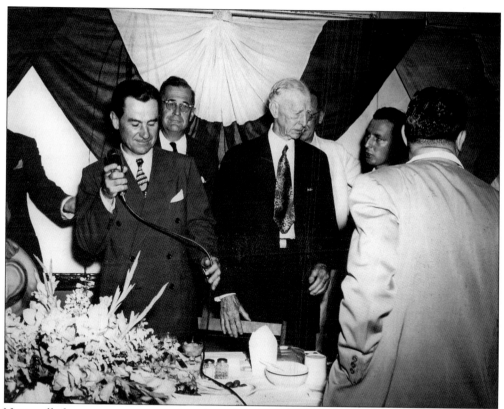

Nationally known newscaster and explorer Lowell Thomas (left) and baseball's Connie Mack, born Cornelius McGillicuddy (center), are shown in this photograph taken on July 1, 1947, when Mack returned to town with his Philadelphia Athletics. (Courtesy of Allen Weathers.)

Connie Mack (1862–1956), major league baseball player and manager, got his start in baseball as a catcher for one season with the semiprofessional Meriden Resolutes. When he returned to Meriden 63 years later, he brought his Philadelphia Athletics to play an exhibition game against the Insilco semiprofessional team at Insilco Stadium. Ten-thousand fans attended the 1947 benefit game that raised over $5,000 for the boys club. (Courtesy of Meriden Historical Society.)

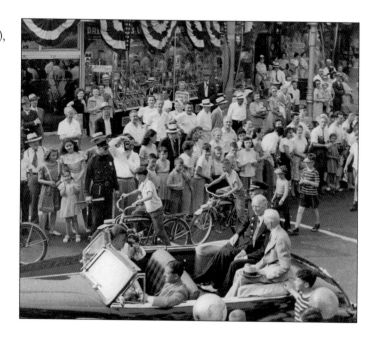

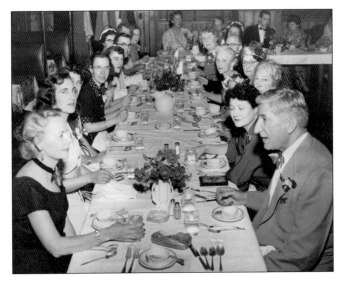

Active since 1934, the Meriden Poetry Society was started under Julia Lansing Hull Warnock and Isyla Powers Lee, editors at the *Meriden Record* newspaper. In 1948, the society published its first anthology, *On Wings of Verse*, with annuals produced since then. Pictured here at an annual society banquet are Lydia Atkinson and Myrtle Cavallo (front left), Connecticut governor Charles Wilbert Snow (front right), and the others are unidentified. (Courtesy of Mario Cavallo.)

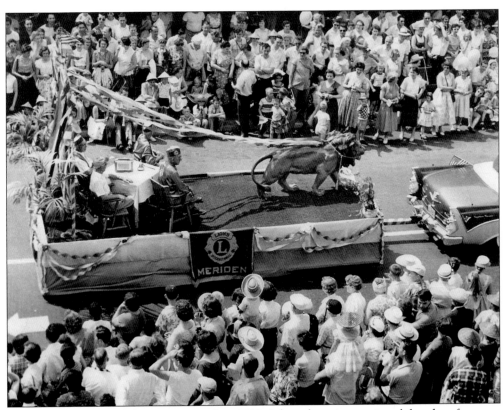

The Meriden Lions Club was organized in 1923. Like other city service clubs, they focus on community support through projects and donations. They sponsor an annual Palm Sunday brunch and an annual duck race on Harbor Brook at Brookside Park. The float sponsored by the Lions Club is featured in this June 1956 photograph taken at the sesquicentennial parade in honor of Meriden's 150th anniversary.

Begun by amateurs in 1948, the Meriden Symphony blossomed into a professional orchestra that lasted for more than 50 years. From Mozart and Tchaikovsky, to pop concerts in Hubbard Park, it provided much-loved musical performances for the community. Its final season was 2002.

Dr. John E. Stoddard (1880–1964) was Meriden's public health director for 24 years. He dedicated his life to medicine, sports, and education. The Stoddard "Silver Bowl" Trophy for Meriden high school football was named in his honor as was the health department building. He was awarded the Gold Key Award by the Connecticut Sportwriters Alliance for his service to sports. Dr. Stoddard delivered 3,465 babies during his career.

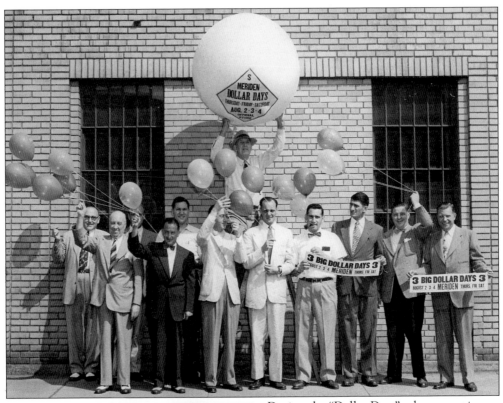

During the "Dollar Days" sales promotion of August 1951, one thousand balloons, with gift certificates worth $1,500, were released by the Meriden Merchants' Bureau. Merchants include, from left to right, Harry Zaintz, Charles Conwell, Carl Schultz Jr., William Israel, Paul B. Baron, George F. Lewis, Gus Kruttschnitt, Robert P. Summit, George Hamrah, bureau president John Sullivan, and Thomas Maddigan. Charles A. Newton of the Meriden Chamber of Commerce holds the large balloon.

Tomie dePaola, author and illustrator of over 200 children's books, was born in Meriden in 1934. He has sold over six million books and received numerous awards including the Caldecott and Newbery Honor awards. All of his *26 Fairmount Avenue* autobiographical books are set in his childhood city of Meriden. He now resides and works in New London, New Hampshire.

News From Home was a monthly newsletter sent to servicemen and women to keep them in touch with Meriden. Inaugurated in 1943, it ended in 1976. Written by Art Barber, executive secretary of the Meriden USO, it was chatty and informative, with pictures and news from the GIs who wrote back. Art always began the four-page letter with "Hi Buddy," bringing cheer and a slice of home to the troops.

NEWS FROM HOME

(A monthly letter from the Meriden U.S.O.
to the City's Men and Women in Service)

No. 9 --- December 1944

Hi, buddy !

Again red-fire parades along Main Street are just a memory, and again Meriden settles back to four more years of Democratic national administration. "That's the way we want it," said Meriden by a margin of 1876, running 844 ahead of Norwalk Lawyer McMahon in his victory over John Danaher for the U.S. Senate, and 1527 ahead of Democrat Hurley's unsuccessful attempt to unseat Republican Governor Ray Baldwin. The 1,000 or so of you who voted, split about even for the city, a Dewey plurality in the second ward (Lewis Ave. section) balancing off Roosevelt edges in other wards. (M.H.S., however, went 2-1 for F.D.R. in a straw vote.)

The Community Fund, including $2,800 for 1945's "News from Home," went over its $192,000 top with $1,302 to spare -- November 20 launched the 6th War Loan with a local goal of $7,837,000. (Meriden's per-capita sales of "E- Bonds" for the entire war period remain right at the top of the State.)

The City fathers made news when they: (1) appropriated $57,000 for a 1945 straightening of Kensington Ave., to encourage a Kensington-Lewis Ave. detour for west-siders working in North-end factories; (2) warmed up prospects for a west-side branch public library at the corner of West Main and Maple; (3) considered, for a central fire station, the purchase of the big H. T. Smith Bldg. at Camp and State St. corner, with Camp St. overpass nearby to avoid grade-crossing tie-ups for west-side fires; (4) approved a commission to draw up a budget for a municipally financed 'teen-age soft drink night club, after a hearing on the subject crowded 250 people--most of them youngsters--in a room intended for 100 or so.

Plans are under way to invest $30,000 to make Curtis Home on Crown Street one of the finest children's homes in the State. Meriden High failed to win a football game---and prospects for basketball glory have been brighter in other years. No more practice black-outs in Conn. U.S.O. Center Director Horace Turner leaves for a higher position in Greenwich. During a 3" snowfall Nov. 16, the large David Yale barn on Yale Ave. was lost in a fire which seemed to illuminate the whole East side.

The local Red Cross set a record on Nov. 16, when, in six hours, 309 people gave pints of blood for you out there who need it. Thirty Meriden people, including Art Nevin and yours truly of the U.S.O. Center Staff, are charter members of the local Gallon Club, having given 8 pints each. Since the normal person's total is 6 pints, we should be pretty anemic by now. Mrs. Ben Prout leads R.C. Nurse's Aide program with over 1,000 hours donated. The local Chapter is planning now its promotion for its March

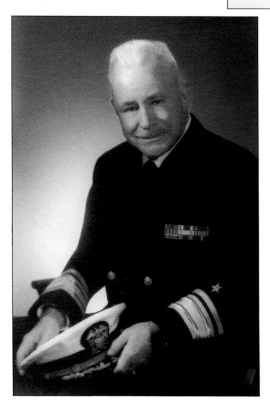

Meriden native Rear Admiral George A. Lange (1903–1977) graduated from Meriden High School in 1922. He was a 1927 graduate of the U.S. Naval Academy. He was serving as executive officer on the USS *Potomac*, President Roosevelt's yacht, and was a White House aide when the Japanese attacked Pearl Harbor during World War II. His distinguished naval career included service in the South Pacific from 1942 to 1945.

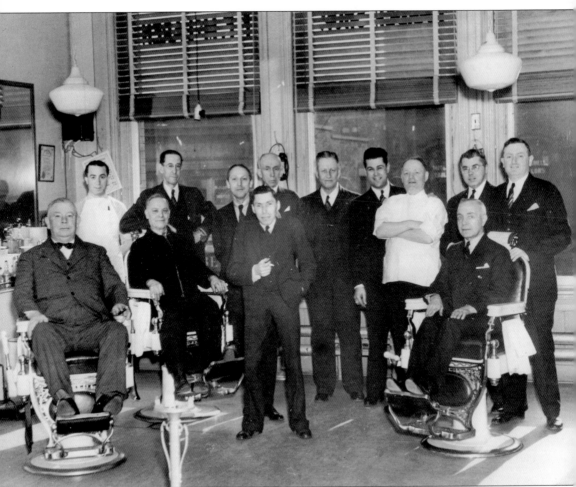

This photograph is humorously labeled, "Final Meeting of Board of Directors of the Colony Club, 30 Colony Street, before eviction, 1937. . . . On motion made and seconded it was voted that this picture not, repeat not, be displayed in any public place lest some of it characters be recognized and apprehended." Pictured here from left to right are (first row) Cornelius J. Danaher (in barber chair), Leonard Marcantonio, Neil Danaher, and Jake Zick; (second row) Tony Ciaburri—barber, Henry T. Shaw, Albert Pelton, John Williams, Dr. Ernest W. Spicer, Joseph DePaola—barber, Frank MacLaren, Francis R. Danaher, and Wesley Davisson. The imminent removal of the top two floors of the four-story Wilcox Block necessitated the eviction. Sears, Roebuck, and Company occupied the corner store in the 1950s when the building had two remaining floors, with the top floor housing offices. The building was razed in 2008.

Five

LANDMARKS AND PARKS

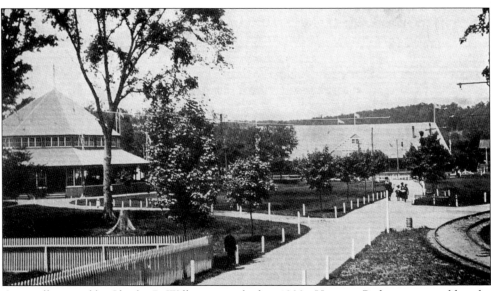

Originally owned by Charles B. Wilkinson in the late 1800s, Hanover Park was soon sold to the Connecticut Company. Located on the northeast side of Hanover Pond in South Meriden, the park was developed as a way to promote their trolley transportation system. People who came to the amusement park by trolley car were charged no admission fee.

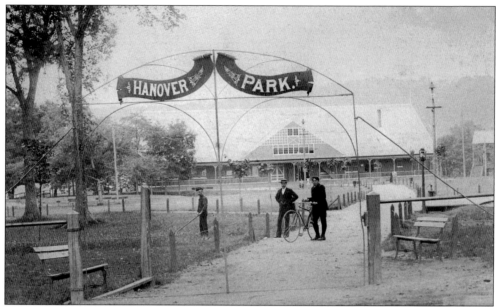

Attractions such as boating, swimming, ball games, balloon ascensions, a merry-go-round, concession stands, concerts, dances, vaudeville shows, and fireworks enticed people to Hanover Park. After the park closed, the property was sold, and in 1951 it became the headquarters for the American Legion Post No. 45, the current tenant. Farther southeast of the pond are several city ball fields. In 1957, that area was named Habershon Park in honor of Herb Habershon, who was devoted to promoting Little League baseball and other sports.

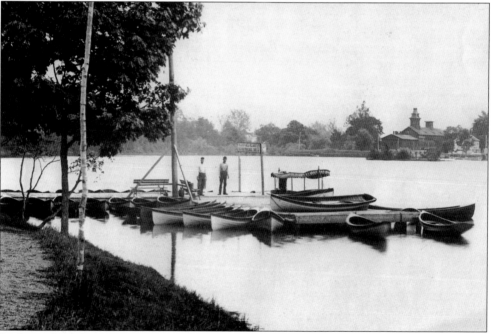

In the early 20th century, Hanover Pond was a popular recreation spot. The sign at the boat dock reads, "The Launch Amelia will make half hour trips daily, fare 10¢." Across the pond, the Meriden Cutlery Company building is visible on the right.

The city developed the west side of Hanover Pond as a bathing beach named Red Bridge Resort. In 1933, it was renamed in honor of Oscar I. Dossin, chairman of the city's first recreation committee. In later years, pollution problems caused the closure of the beach. This bathhouse became home to the Meriden Humane Society, which made alterations to the structure. It has been restored to resemble this original view and now houses the Quinnipiac River Watershed Association.

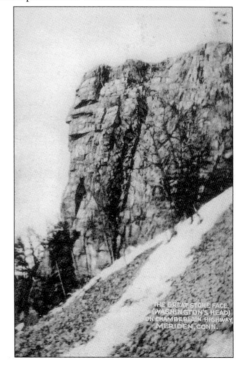

This early postcard pictures the craggy peak off Chamberlain Highway known as Washington's Face. It is near Cathole Pass, where in former times wild cats and game animals were common. A resemblance to George Washington was seen in the natural rock profile, but time and erosion took their toll and made it difficult to recognize.

Considered by many to be the prettiest park in the state, 1,800-acre Hubbard Park was given to Meriden by Walter Hubbard in 1900. In addition to the annual daffodil festival, it features hiking, concerts, dinosaur tracks, and fishing for children. Over 100,000 visitors enjoy the holidays when thousands of lights adorn the scenery. Shown here in 1950, the park was listed on the National Register of Historic Places in 1998.

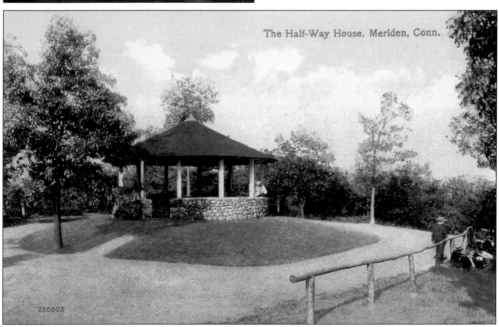

The Fairview Pavilion in Hubbard Park was built in the late 1800s as a halfway point between Mirror Lake and Castle Craig. It is located on Fairview Point, elevation 500 feet. It was turned over to the town in 1900 by Walter Hubbard. When new, it was a popular place to picnic and enjoy the panoramic view. After a two-year renovation by volunteers, it was rededicated on April 19, 2009.

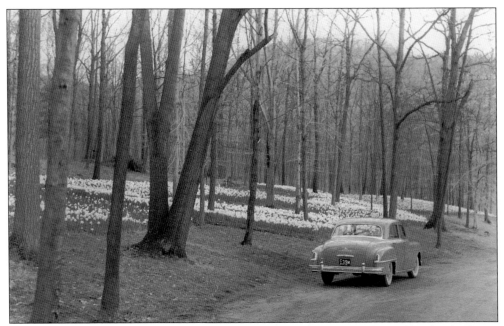

In 1949, park superintendent James Barry had 1,000 daffodil bulbs planted in Hubbard Park. Shown here in 1951, each year additional bulbs were planted, and now the park boasts more than 600,000 daffodils. In 1953, Mayor William J. Cahill issued the first Daffodil Day proclamation. The first official Daffodil Festival was held in 1979. The annual event features top-notch entertainers, a parade, amusements, fabulous food, and fireworks.

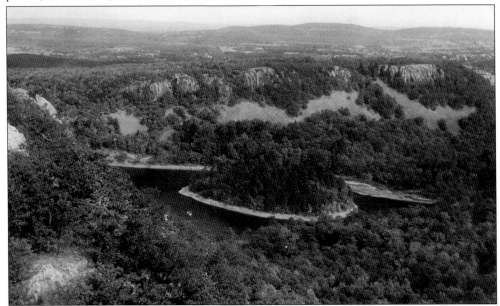

Mine Island and the surrounding Merimere Reservoir are shown in this dramatic photograph taken from Castle Craig Tower in September 1945. Before it was flooded to create the city's first reservoir in 1869, the island was a hill surrounded by land. Former proprietor William Johnson hoped that gold could be excavated from the area, but it never yielded anything except small quantities of iron pyrite.

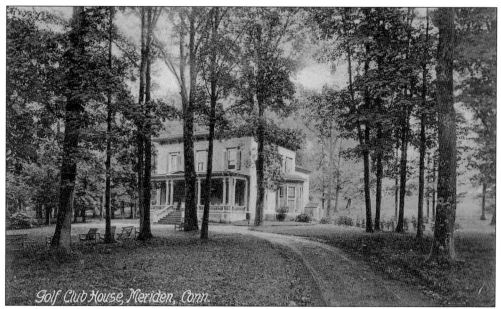

Golf Club House, Meriden, Conn.

In 1899, when their first golf course proved too small, the former William L. Bradley (1826–1894) estate on Bradley Avenue was leased by the Meriden Golf Club for their second course. Bradley had earlier moved to Massachusetts, where he developed the world's largest fertilizer factory. Although the clubhouse shown in this postcard view is still standing as a private home, by 1910 the rest of the estate was developed for housing.

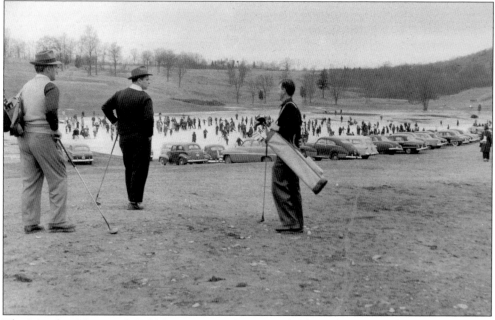

The Meriden Municipal Golf Course opened on Westfield Road in 1929. The fee was 50¢ for 18 holes. George Hunter II was golf professional and greenskeeper at the course for 35 years, retiring in 1965. After he died in 1966, the course was renamed in his honor. Pictured here in 1954, golfers and skaters shared the grounds. The highly rated municipal course hosts an annual city golf championship.

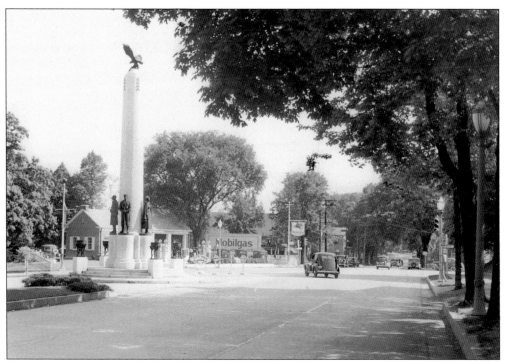

Pictured here in 1939 is the World War I Memorial Monument, designed by sculptor Aristide A. Cianfarani. Dedicated in 1930, the sculpture is located at the intersection of Broad and East Main Streets and marks the beginning of "Memorial Boulevard," the grassy median section of Broad Street where other memorials have since been erected. The names of those who died in service are inscribed beneath the statue's buttresses.

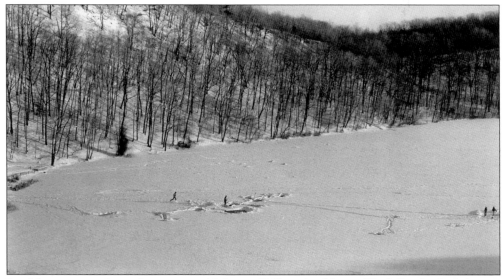

Ice fisherman are shown here on a cold day in 1968 at the 76-acre Black Pond, which lies on the Meriden-Middlefield border. The surrounding mountains and cliffs make the area scenic in summer or winter. The pond is a favorite with kayakers, hikers, anglers, and bird watchers. (Copyright Ernie Larsen)

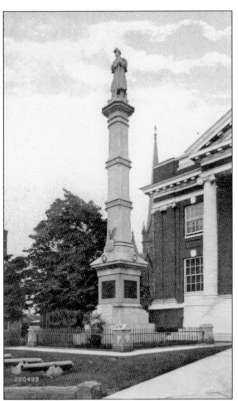

This Civil War monument that stands on the west side of city hall was erected in 1873. The 38-foot monument is made from Westerly granite. It lists the 158 Meriden men who died to save the Union. On top is the figure of a 7-foot Union private who stands at parade rest. It was erected at a cost of $11,000 of which the Merriam Post members contributed $1,000.

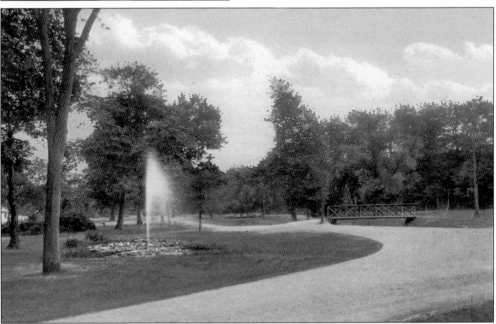

The land for Brookside Park was purchased by Walter Hubbard in 1901 and given to the city for a park. Shown on this early postcard, it contains 13 acres extending from Camp Street to Broad Street. Harbor Brook runs through the park and is the site of the Lions Club annual duck race in May. The rubber duck race is one way the service club raises money for charitable causes.

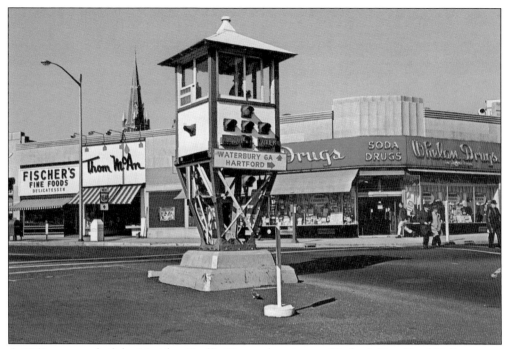

A 1960s postcard of the Meriden Traffic Tower also pictures Fischer's Fine Food Delicatessen, Thom McAn shoes, and Whelan's drugstore. Fischer's started on East Main Street in 1943 as Fischer's Cooked Food Shop. In 1963, they moved to the store pictured here at 13 West Main Street. By 1973, they were located at 21 Colony Street. A 2008 renovation brought with it the name change to Pies Ons pizzeria.

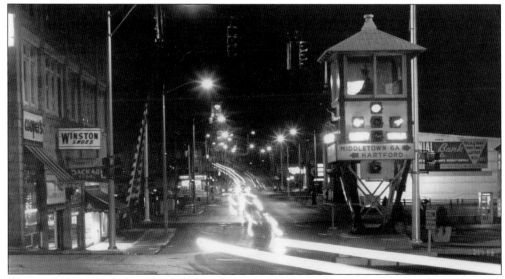

This 1967 photograph shows both the traffic tower and the electric traffic signals, which were soon to replace it. In the Hall and Lewis Block on the north side of West Main Street, Cooper's, Winston Shoes, and Parmett's Package store are visible, along with the railroad crossing gates. Traffic still has to stop for the occasional train crossing West Main Street. (Copyright Ernie Larsen)

In the late 1800s, Henry N. Johnson planned to develop part of West Peak as an area of vacation cottages and hotels. W. H. Catlin bought a lot in the Percival Park development and built this house around 1890. Called Katlyn Kottage, his family vacationed there until about 1914. Several years later, the Catlins rented and then sold the house to the YWCA for a vacation cottage. It was razed by 1940.

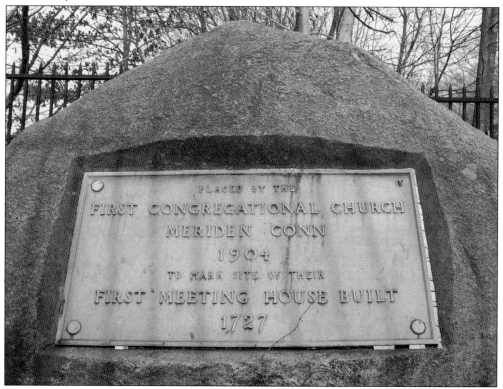

In 1904, this plaque was placed near the eastern end of Ann Street by the First Congregational Church. It commemorates the site of the first meetinghouse in Meriden, built in 1727. Several years later, the Reverend Theophilus Hall became the pastor, and a second meetinghouse was erected in 1755. Hall died in 1767 and is interred in the first burial ground, east of the meetinghouse site.

Six

TRANSPORTATION

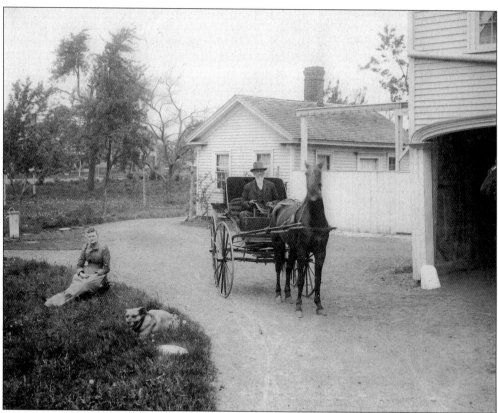

The pace of life was slower when this picture was taken of the Aaron L. Collins family in the 1890s. A horse and buggy traveled less than 10 miles per hour. Mr. Collins was president of the Wilcox Silver Plate and the Meriden Cutlery Company. His extensive property was located near the site of the present-day Victoria Towers apartment building on East Main Street.

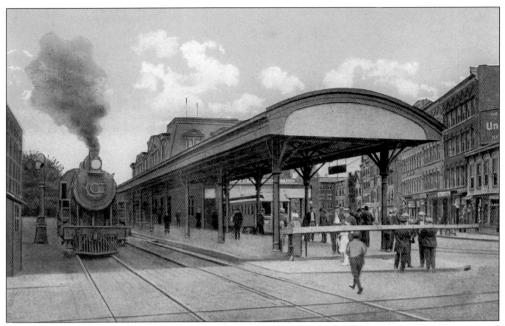

Despite the protests of some who feared the new form of travel, the first train to Meriden arrived in 1838. Various depots and stations accommodated travelers until the brick station pictured on this early postcard was built in 1882. It served for 60 years before being razed to make way for the 1942 station.

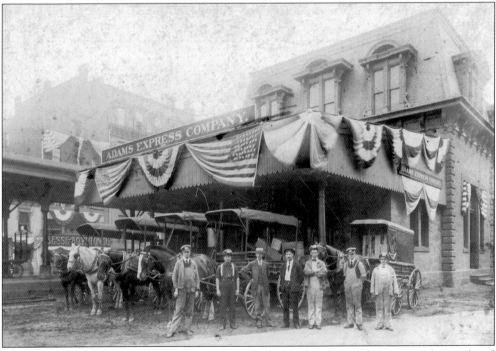

In 1906, the Adams Express Company employees posed with horses and wagons at their railroad station office. The Besse Boynton Company, a popular clothing store, is just visible on the left, in back of the station.

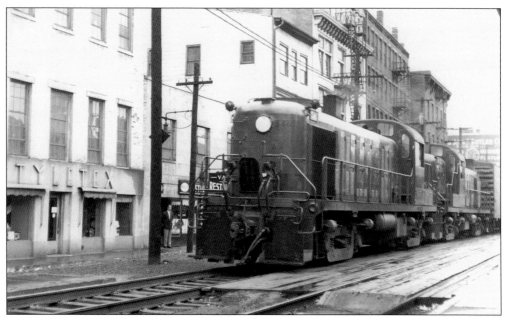

Many of the downtown stores that fronted Colony Street had a rear entrance close to the railroad tracks. Visible to the left of the train in this 1953 picture, the Styletex womens' clothing store grew to three stores before closing in 1972. The shop was founded by Samuel Beloff in 1920 and was located at 9 Colony Street for several decades. In the early 1970s, Beloff's Women's World opened at 192 West Main Street.

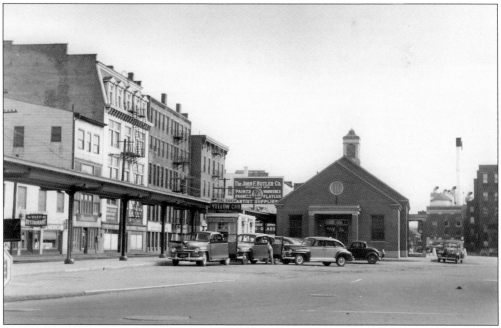

When the old 1882 railroad station was razed, this one was built to replace it. On opening day, September 21, 1942, the important community event made headlines on the front page of the morning paper. A celebratory luncheon was held at the Winthrop Hotel. The State Street station, pictured here in May 1950, served until 1970, when the present station was built on a smaller scale.

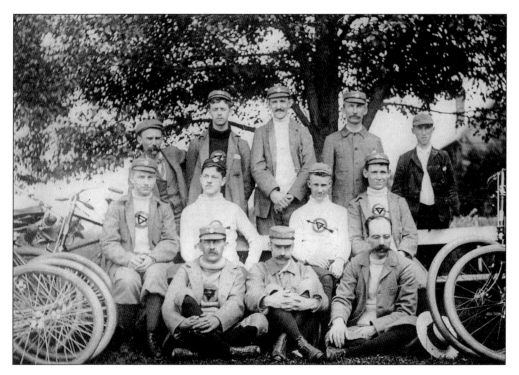

By the 1890s, bicycles had become an inexpensive and popular form of transportation for both men and women. Bloomers and special bicycle costumes gave women new freedom from long skirts. The Meriden Wheel Club, organized in 1880, was the second oldest cycling organization in the state. Sponsored by the club, a national cycling tournament was held at the State Fair Grounds in Meriden on August 29, 1896. The city band played during the races. The club's rooms in the Palace Block were open day and evening. Entertainment at Hanover Park included a concert and a balloon ascension with a parachute drop by 19-year-old aeronaut Nina Madison.

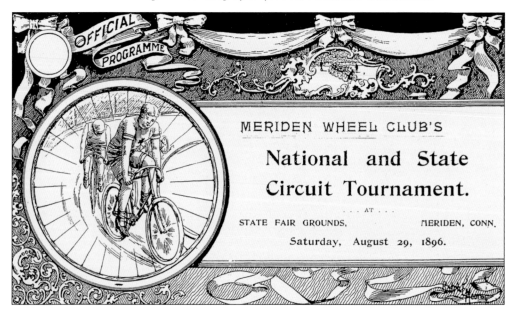

OFFICIAL PROGRAMME

MERIDEN WHEEL CLUB'S

National and State
Circuit Tournament.

. . . AT . . .

STATE FAIR GROUNDS, MERIDEN, CONN.

Saturday, August 29, 1896.

The electrified wires that powered the trolley cars can be seen in each of these early views. In the picture below of the Colony, Britannia, and Griswold Streets car, two women can be seen peering out at the camera.

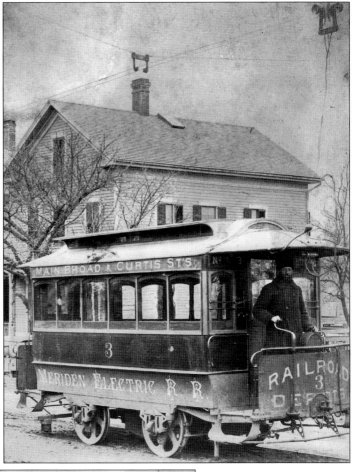

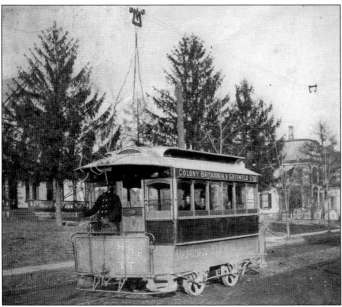

The first horse-drawn trolley car ran March 2, 1887, on Colony Street. The fare was 5¢. In 1888, a disastrous fire at the Pratt Street stable killed 79 trolley horses. This provided the impetus to try electrified cars, but because the system was not perfected, there was a return to horses until 1893. For 35 years, the cars ran all over town and between cities. The last trolley ran on East Main Street to Pomeroy Avenue on September 27, 1931. Buses were substituted the following day.

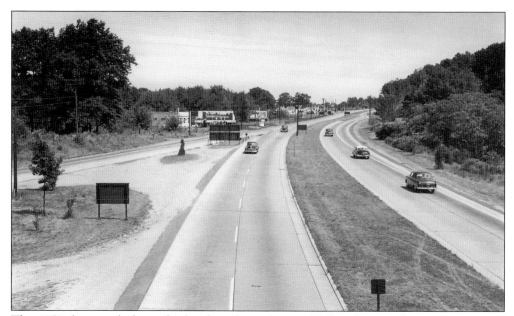

This 1952 photograph shows the four-lane, limited-access Wilbur Cross Parkway at its junction with North Broad Street. The Meriden section of the road opened in 1946. Named for former governor Wilbur Cross, it was a toll road until 1988. The highway runs northeast from the Sikorsky Bridge in Stratford to Meriden, where it merges into U.S. Route 5, North Broad Street, and continues north as the Berlin Turnpike.

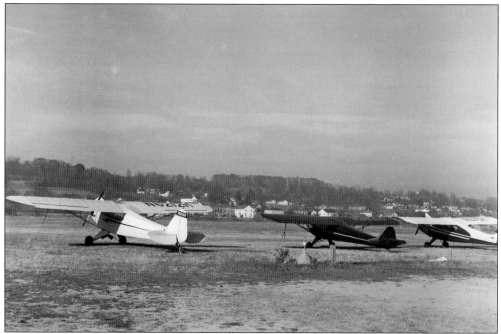

Founded in 1928, Meriden Markham Airport was renamed in 1962 in honor of Maj. Ernest L. Markham, manager of the airport for 32 years before his retirement in 1960. The 137-acre airport borders on Evansville Avenue in South Meriden. Much of it lies in the adjacent town of Wallingford, but it is owned by the City of Meriden. This photograph was taken in 1953.

Seven

RELIGION AND EDUCATION

The first Meriden High School, at the corner of Liberty and Catlin Streets, was formally opened in 1885. The Victorian Romanesque structure was used as a high school until overcrowding necessitated a new building on Pleasant Street. After 1912, it housed various city departments until renovation, and it was used as a high school annex from 1948 through 1958. It has housed the board of education offices since the mid-1980s, when extensive renovations were completed.

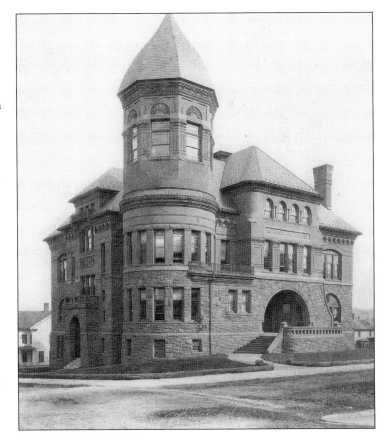

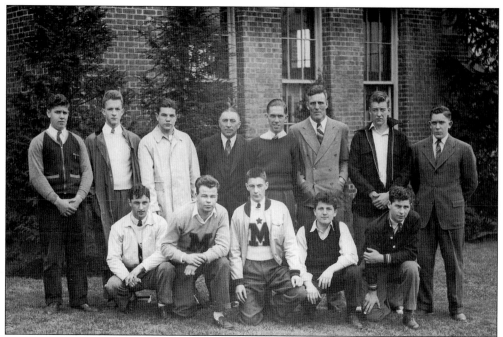

Pictured here is the 1941 Meriden High School football team. Team members are, from left to right, (first row) George Allis, Robert Ketelhut, Owen Beach, Guido D'Incecco, and Edward DeAngelis; (second row) Edward Kwiatowski, Wayne Smith Jr., Malcolm King Jr., Frank J. Barnikow (coach), William Dickson (manager), Russell Doran, unidentified, and Joseph Delaney.

In 1913, this new Meriden High School opened to relieve the overcrowding in the old building. Shown here in 1950, the Pleasant Street site was in use until 1958, when Maloney and Platt High Schools opened. Washington Junior High School occupied the building from 1959 until 1984 when the student body, combined with Jefferson Junior High students, moved to the new Washington Middle School on Broad Street.

Because of its central location and accessibility, Meriden was chosen as the site for the State Reform School in 1854. In 1893, the name of the multi-acre Colony Street facility was changed to the Connecticut School for Boys. By then, the philosophy of housing all the boys in a central building had changed to one of segregation by age and dispersal among cottages with a family-like environment.

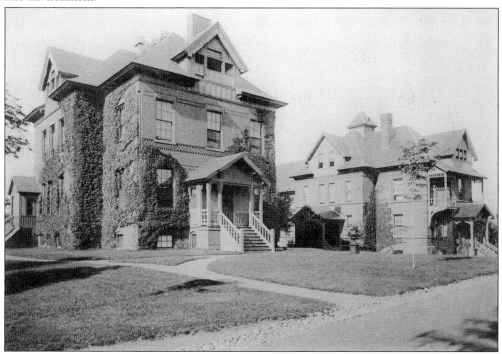

Although early conditions at the Connecticut School for Boys were harsh, later superintendents instituted reforms that improved conditions. The cottage system provided closer supervision and more personal attention. The boys enjoyed sports and other activities. Most boys went home for holidays. On June 30, 1922, there were 379 boys in residence. They ranged in age from 5 to 20. Some of cottages are shown in this 1890s photograph.

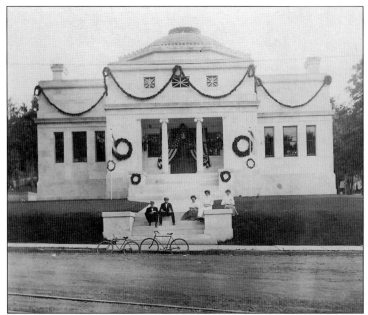

The Curtis Memorial Library is shown decorated for the 1906 centennial. The H. Wales Lines Company constructed the marble building at a cost of nearly $75,000. The East Main Street structure served as Meriden's library for 70 years, until the present library was erected on Miller Street. The former building is now the Augusta Curtis Cultural Center, where lectures, exhibits, and programs are held. It may be rented for special events.

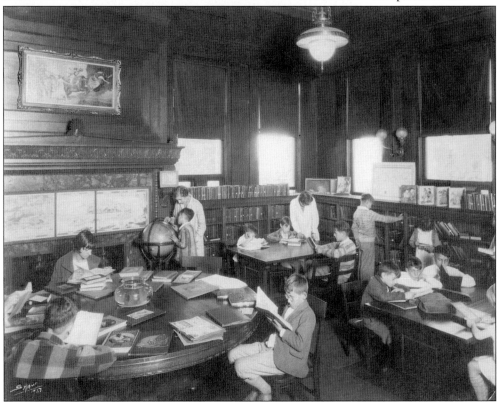

This 1927 view inside the old Curtis Memorial Library shows how the children's room looked when it was located on the first floor. The room later housed the reference department. The former library is now the home of the Augusta Curtis Cultural Center where educational programs and all types of special events are held.

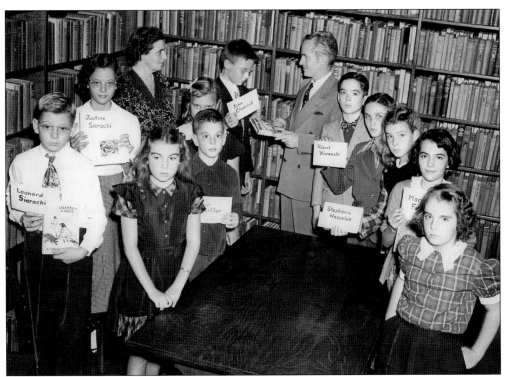

In this photograph are the children who participated in the National Library Day program at the Curtis Memorial Library on October 4, 1951. Mayor Howard E. Houston is shown presenting the children with prizes for their participation in the library's summer reading club. The reading program was billed as the "Golden Anniversary Treasure Chest" in honor of the library's 50th year of service to the community.

Marion E. Cook (1912–2001) and Msgr. Joseph M. Griffin (1897–1975) are shown at the center of this October 1972 photograph next to the new library, which was being constructed on Miller Street. Miss Cook was director of the library from 1955 until her retirement in 1983. Monsignor Griffin was pastor of St. Rose of Lima Church and longtime member and chairman of the library board.

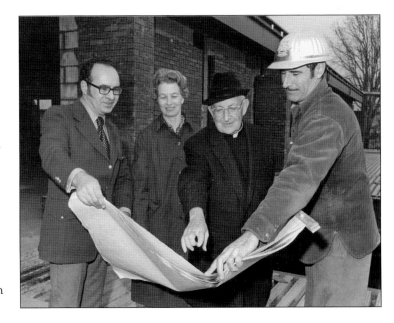

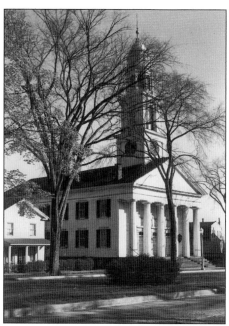

This 1949 photograph shows one of the most historic landmarks on Broad Street. Built in 1831 for the First Congregational Society of Meriden, it became known as the Center Congregational Church after 1848 when the society divided. The group that retained the name First Congregational is the group that moved to Colony Street in what was then called the "corner" section.

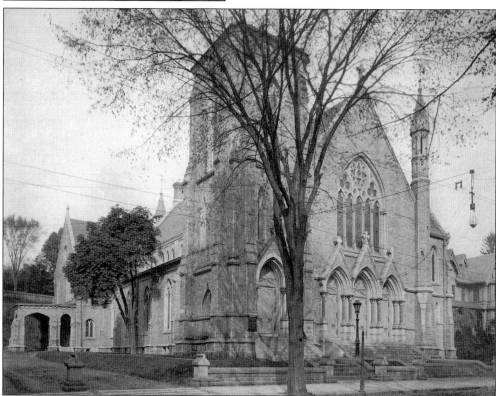

The First Congregational Church building at 62 North Colony Street was dedicated on April 2, 1879. The congregation was the first religious society in Meriden, and a commemorative boulder marks the site of their original 1700s meetinghouse on Ann Street. This Victorian Gothic structure was their fifth building. It looks much the same today as in this 1890s photograph.

In the late 1700s, Meriden's first organized Episcopal group met at a private home. Their first church was built on the west side of Broad Street in 1807; the second was built in 1848 on the east side of Broad Street. The present St. Andrew's Church was erected in 1867 at the corner of Liberty and Catlin Streets. The distinctive red and gray roof has guided airplane pilots as a reference point.

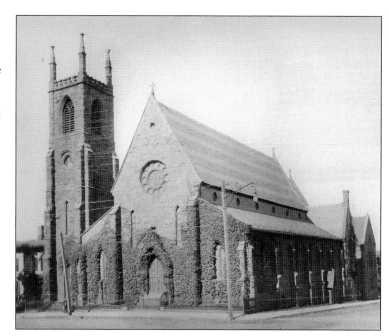

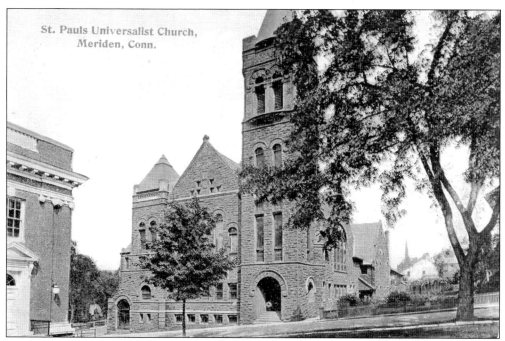

The First Universalist Church of Meriden began in 1854, and a wooden church was erected on Norwood Street in 1860. The brownstone St. Paul's Universalist Church pictured on this postcard was constructed nearby in 1893. The Unitarian Universalist congregation downsized to a smaller structure on Paddock Avenue in 2002. Vacant for several years, in 2007 the Holy Word Foundation Ministry Church moved into the building and refurbished it.

Begun in 1848, St. Rose of Lima Church was the first Roman Catholic parish in Meriden. After locating in a former Episcopal church, this building was erected on Center Street in 1856. By 1916, the church was extensively remodeled with two towers and a west front replacing the former single spire shown in this 1892 view. Originally serving Irish immigrants, today St. Rose has a sizeable Hispanic apostolate.

The First Baptist Church of Christ was organized in 1786 in what was then the town of Wallingford. After Meriden incorporated in 1806, the church officially became the First Baptist Church of Meriden. A monument on Murdock Avenue marks the site of their first church, used from 1801 to 1816. There were several more moves before the present Broad Street church was dedicated in 1848. This photograph was taken in 1946.

In 1830, the first Methodist meetinghouse in Meriden was constructed on East Main Street. By 1844, the congregation had moved to Broad Street. In 1866, a new Gothic-style church was erected at the corner of East Main and Pleasant Streets. It was destroyed by fire in 1941. In 1949, the first service was held in this building, which is now known as the First United Methodist Church.

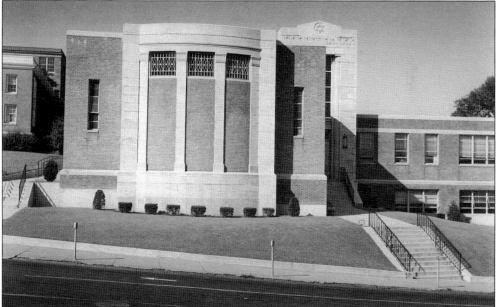

The first Jewish synagogue in Meriden was constructed on Cedar Street in 1891. A larger building was erected on the original site in 1908. By 1952, the growing congregation required more space and Temple B'Nai Abraham was constructed at 127 East Main Street. Boston architect Charles Grecko designed a structure "that would be modern yet harmonize with the colonial appearance of the surrounding area." This view was taken in 1954.

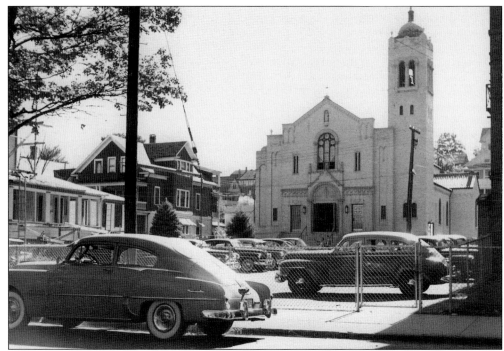

Our Lady of Mount Carmel Roman Catholic Church was first formed in 1884 to serve Italian immigrants who had settled mostly in the northwestern part of Meriden. A modest wooden church served the parish until the present church, pictured here in 1952, was built on Goodwill Avenue in 1935. The Lombard architectural style of Northern Italy was chosen for the red-tiled building that accommodated 620 people.

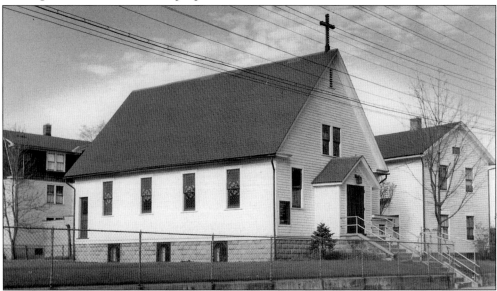

Shown here in 1950, the Italian Baptist Church building was erected on Springdale Avenue in 1912. In 1958, the congregation was renamed Grace Baptist Church, and a new structure was erected around the corner on Windsor Avenue. Since 1997, it has housed Grace Fellowship. The original building is used as a church hall.

The Polish parish of St. Stanislaus Bishop and Martyr was established in 1889. In 1892, their first church was built on the corner of Jefferson and Oak Streets; prior to that time, Polish immigrants had worshiped at St. Rose and St. Laurent Churches. Their second building, pictured here in August 1953, is located at the corner of Pleasant and Olive Streets. The church was dedicated on September 7, 1908.

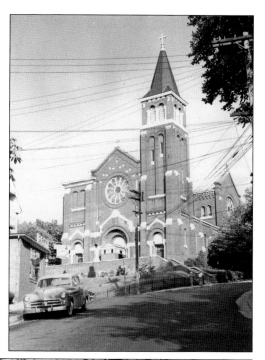

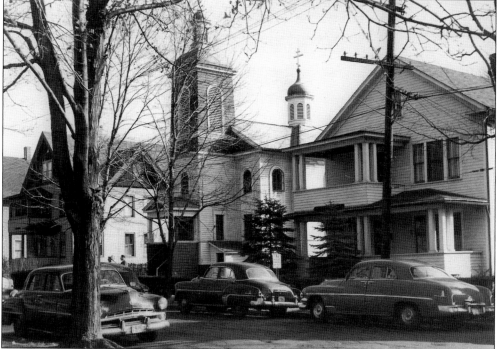

Founded by Russian immigrants in 1911, Saints Peter and Paul Orthodox Church was located in this building at 39 Bunker Avenue from 1912 until 1956. They moved to their present church on Park Avenue in 1956. The Seventh Day Adventists bought the Bunker Avenue building in 1957, several years after this 1954 photograph was taken. Since U.S. Interstate 691 went through, none of the buildings pictured here are still standing.

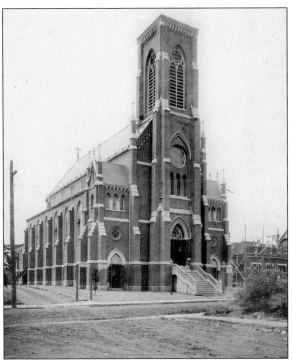

St. Laurent Catholic Church celebrates the 130th anniversary of its founding in 2010. The cornerstone of the French Catholic church at 123 Camp Street was laid in 1881. This photograph was taken around 1892, before the present spire was placed on the bell tower.

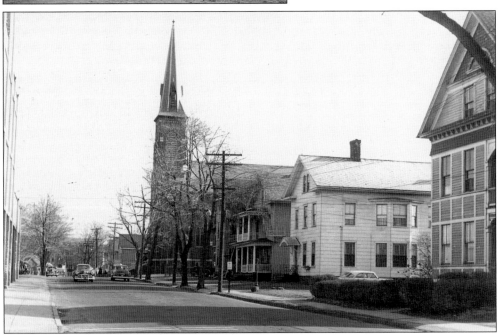

This 1954 view of Camp Street shows St. Laurent Church with its spire in place. St. Laurent School, which was located next to the church, was erected in 1903. The school closed in 1998 and was demolished in 2004. Today Meriden has about 580 students enrolled in the three Catholic schools of St. Joseph, St. Stanislaus, and Our Lady of Mount Carmel. In 1959, the number of parochial students was 2,400. In addition to the loss of St. Laurent, declining enrollment has led to the closing of St. Rose, St. Mary, and Holy Angels Schools.

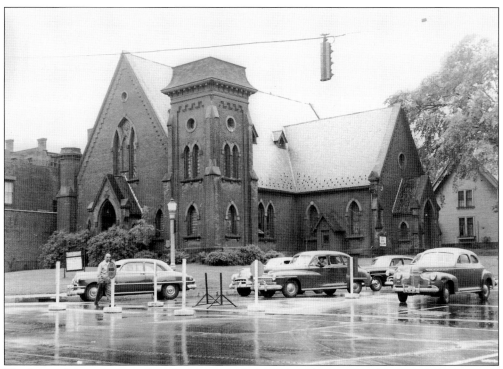

The Main Street Baptist Church was erected in 1868 at the corner of Crown and East Main Streets. It was originally known as the West Meriden Baptist Church. The tower was removed in 1946, seven years before this picture was taken. When the Baptists closed the church in 1997, the building was sold to Faith Center Church of God, its present occupant.

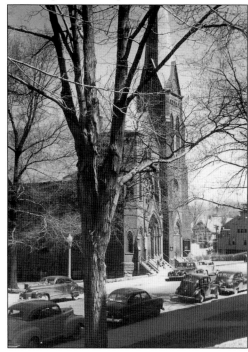

St. John's Lutheran Church was founded in 1865, and this church was constructed on Liberty Street in 1892. This view was taken in 1950. In 1959, when the steeple on the old church became unstable, it was removed. The congregation moved to their new church at 520 Paddock Avenue in 1971. The old church was demolished that year to make way for the parking lot of the new library.

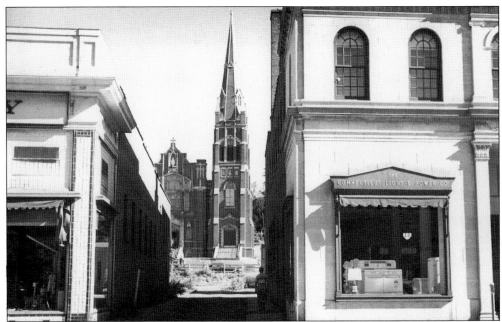

This 1952 view looks from West Main Street through to St. Mary's on Church Street. The church was founded by German Catholics in 1890, with a first wooden building being dedicated in 1891. The present sanctuary was dedicated in 1913. In the right foreground is the office of the Connecticut Light and Power Company at 39 West Main Street. The structure now houses an art gallery and restaurant.

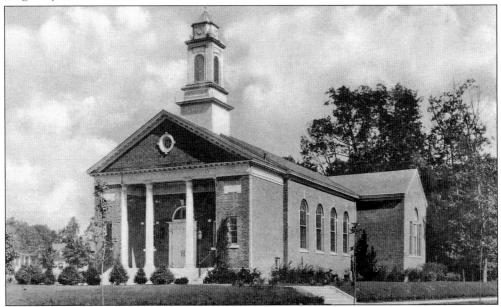

The Christian Science movement in Meriden started in 1894 and met in homes and various buildings until growth necessitated a permanent meeting place. Shown on this early postcard, the church building on Winthrop Terrace housed the First Church of Christ Scientist for many years. Designed by local architect Lorenzo Hamilton, the Georgian-style structure was erected in 1922. It is now home to the Church of God World Mission.

Eight

BUILDINGS AND STREETS

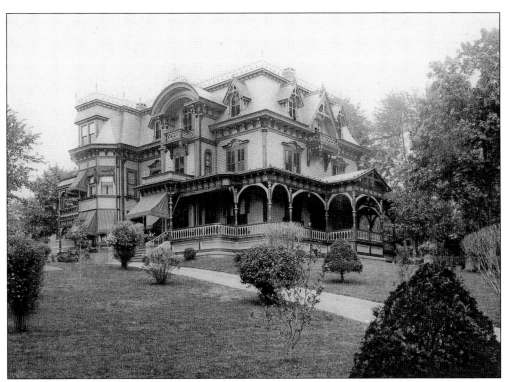

Industrialist Nathaniel L. Bradley (1829–1915), cofounder of the Bradley and Hubbard Company, occupied this mansion at 320 Colony Street. This is a south view as it looked in 1892. The house existed until the 1930s when Bradley's son Clarence willed the property to enable the creation of the Bradley Home for the aged. The original carriage house still stands and is now used for a children's day care center.

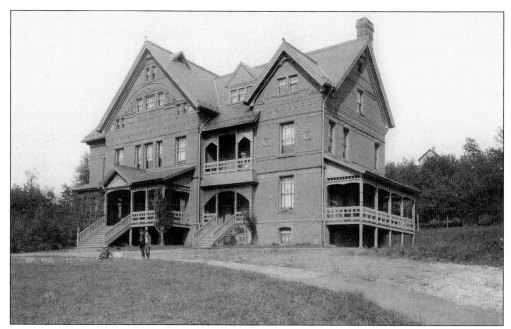

In 1884, the Curtis Home was founded by industrialist Lemuel J. Curtis in conjunction with St. Andrew's Church. This brick building on Crown Street was opened as a home for widows and orphans but later became the children's building. The home has had several additions and renovations over the years, but this structure was razed in 1973 when a new children's building was completed.

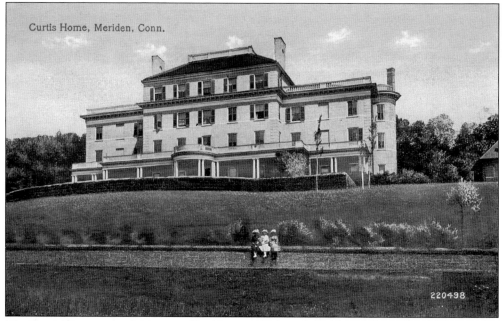

The Curtis Home erected this second building in 1894 as a home for elderly women. Because of its color, it became known as "the Yellow Building," and it has also been called the "Ladies Building." It looks much the same today as in this early postcard. The Curtis Home no longer cares for children, concentrating instead on serving the elderly through residential and specialized care.

Built in 1859, the former Collins residence was located at 69 Colony Street. Longtime home of Sarah E. Collins, who died in 1949, the home had belonged to her parents, Charles and Sarah Brooks Collins. The former post office site was once part of the Brooks family farm. Permanent Building and Loan Association acquired the Collins house in January 1955, and it was razed that October.

By May 1950, the Collins homestead was rented office space. Next door was Squire Insurance, founded in 1826 by Dr. Israel Hough. In 1855, when Henry C. Butler became a partner, it took his name. Butler's grandson Wilbur H. Squire joined the firm in 1877. When the agency branched out into travel and real estate it had two divisions, W. H. Squire Company Inc. and Squire Travel Agency, Inc.

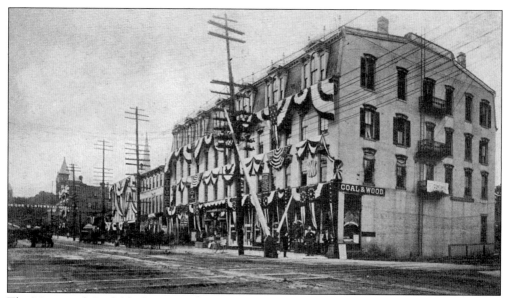

The Morse and Cook block was located on East Main Street, opposite State Street and close to the railroad tracks. Erected in the mid-1870s, it lasted until the redevelopment of the 1960s. This 1906 postcard shows the structure festooned with bunting in honor of Meriden Centennial Week. All of Meriden joined in the festivities of Old Home Week that marked the 100th anniversary of the town.

At the time of this May 30, 1953, photograph, the commercial tenants in the Morse and Cook Block on East Main Street included Fischer's Fine Foods, Jay Bee Lunch, Tiny Town furniture and toys, Variety News, Yale Clothing, Cowl Advertising signs, the Sehl Insurance Agency, and C. J. Hayek Jewelers. The building also contained residential apartments.

Manufacturer Walter Hubbard (1828–1911), who started the Bradley and Hubbard Manufacturing Company with his partner Nathaniel L. Bradley, is best known for his gift to the city of Hubbard Park. In 1852, Hubbard married his partner's sister, Abby Ann Bradley. She died less than six months later, and he never remarried. This view shows Hubbard's house, at Washington Place, as it looked in 1892. Today the lot is vacant.

On the left of this 1890s view of State Street, geraniums are visible in the windows above the hack and livery stables at No. 35. To the right, in the International Order of Odd Fellows Building of the Pacific Lodge No. 87, Arthur H. Gardner and Edgar C. Manwaring operated the Half Dime Lunch Room, which advertised "the best place in Meriden to get a square meal."

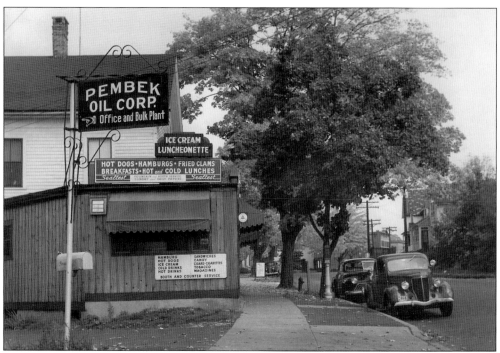

The Westerly Luncheonette was located at 351 West Main Street as shown in this 1949 photograph. Pembek Oil Corporation was nearby at No. 357; both were west of Bradley Avenue.

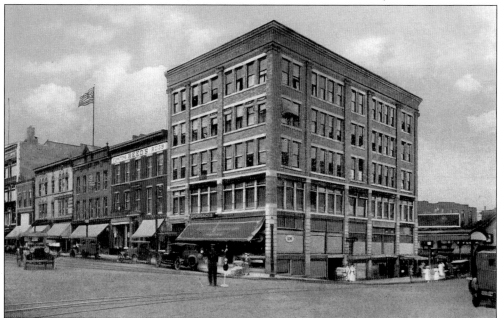

The Hall and Lewis block was constructed around 1912 at the northeast corner of Colony and West Main Streets. It has also been called the Cherniack Building and the Grace Building. An exciting event in the early life of the structure was when downtown merchants sponsored an athletic young man to climb up the face of the building and deliver advertisements as he ascended. At each level the "human fly" stopped to address his audience. The crowd applauded when he reached the top.

Washington Street, at the corner of Colony Street, is pictured in 1952 before the boys club was erected on the north corner in 1956. Now the expanded Boys and Girls Club of Meriden fills most of the space between Colony and Lincoln Streets. The onion-domed house is gone.

Among the oldest boys clubs in the nation, the Meriden Boys Club opened on March 27, 1888, on Veteran Street. After several moves, the club constructed a permanent home at 15 Lincoln Street in 1956. This 1957 view shows the building from the Colony Street side. In 1999, girls became full members. After an ambitious construction project, the newly expanded Joseph F. Coffey Boys and Girls Club of Meriden was dedicated in 2000.

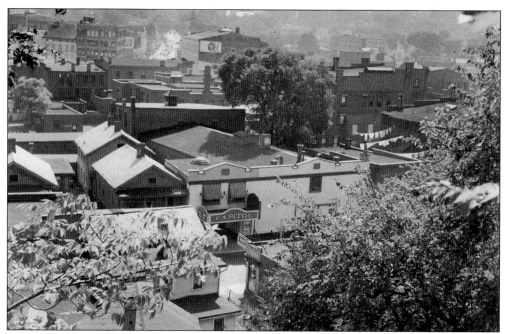

Visible in this 1949 view of downtown is the Capitol Theater on Grove Street. It originally opened as a silent-movie theater in 1915. The theater was renovated and reopened on October 17, 1930. Like many movie houses during the 1930s, dishware was given away as a promotion to increase attendance. A. Leo Ricci was the longtime owner. Despite efforts to save the building, downtown's last cinema was razed in October 1990.

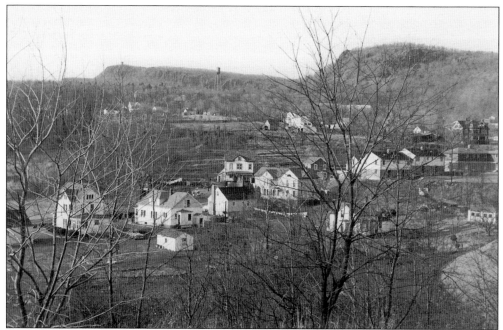

This 1954 photograph was taken from the top of Springdale Avenue. Castle Craig is visible in the distance on the upper left. The water tower, seen to the lower right of the castle, was finally dismantled in 2009.

Meriden's oldest house was built by Solomon Goffe about 1711. Located at 677 North Colony Street, it has had a succession of owners and uses. For several decades, it housed a restaurant known as the 1711 Inn, pictured here in 1949. The house was vacant when the Napier Company presented it to the city in 1977. Extensive restoration was done before it opened as a museum in 1986.

At the 1711 Inn, where banquets and weddings were once held, costumed guides now conduct events that demonstrate life in the 18th and 19th centuries. The building is owned by the city with volunteers running and maintaining the living history museum.

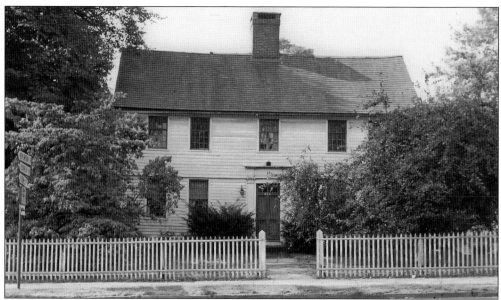

The Moses Andrews Homestead, at 424 West Main Street, was constructed around 1760. Episcopal services were held in the house from the 1770s to 1810. Family owned until 1864, the house went through neglect and rescue as a school, apartments, and a day care center. After 1940, the Meriden Historical Society gained custodianship, and in 1954 a major restoration was sponsored by the Cuno Foundation. Now city owned, the society maintains the museum's interior.

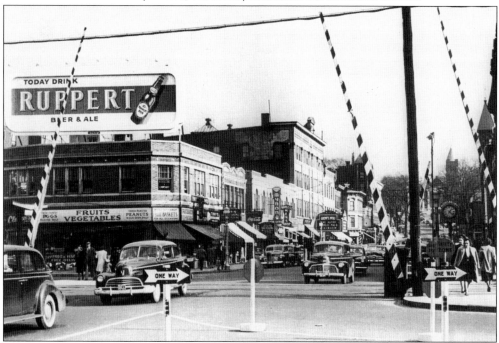

In this *c.* 1950 view of East Main Street, the Loew's Poli Theater marquee features the movie *Saddle Pals* with Gene Autry, America's singing cowboy. Myron's Jewelers, Brills Men's Shop, Liberty Shoe Repair, and Jay-Bee Soda Shop were all in the same 22 through 56 block of East Main Street. Across the street, the clock marks the front of the Meriden Savings Bank.

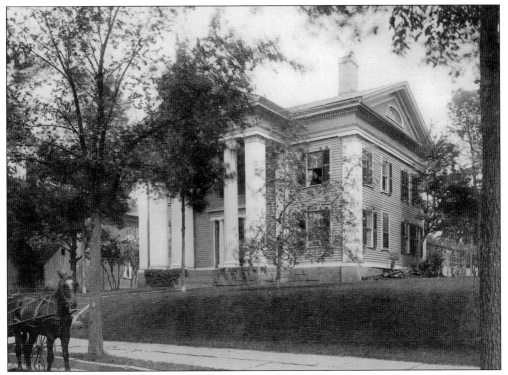

In 1830, this mansion was built by Partrick Lewis at 497 Broad Street. It contained eight fireplaces and boasted an impressive pediment and columns with ionic capitols. Eli Coe Birdsey bought the building from Lewis, and the Birdseys occupied it until 1929. Upon the death of Ida Birdsey, the home was left under her husband's will to the Sons of the American Revolution. They declined to accept it because of expensive upkeep. In 1953, it was converted into a 12-apartment complex. It was razed in 1964 to build a Texaco gas station. When Stop and Shop grocery store was erected on the site in 1999, a rediscovered slab inscribed with the 1830 date was moved across the street to the Center Congregational Church.

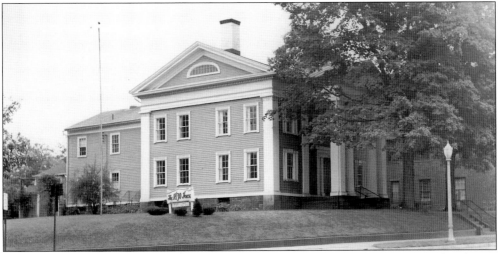

This is the Birdsey Mansion as it appeared in 1950, when it housed the short-lived 1830 House restaurant.

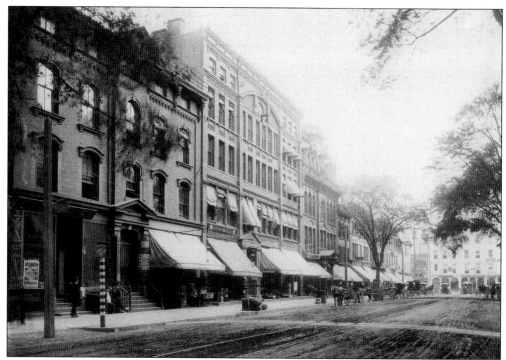

The east side of Colony Street is pictured here as it was in 1892. In the right distance, the Palace Block can be seen on West Main Street. The elegant 1870 building once housed two local lodges of the Masons, the former Young Men's Total Abstinence and Benevolent Society (also known as the "Tabs"), and the Meriden Wheel Club.

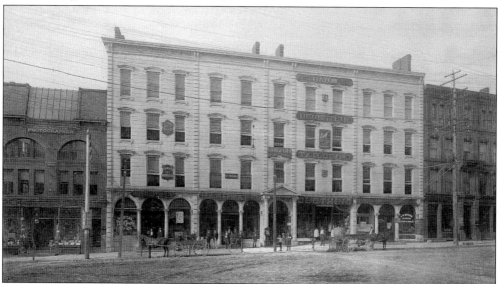

In the 1890s, the most prominent sign on West Main Street's Palace Block was for Baum and Bernstein, tailoring and clothing. The block housed photographer Frank Wheeler, dentist Dr. Theodore S. Rust, physician Dr. Harold A. Meeks, the Postal Telegraph Cable Company, Ellsbree drugstore, Mather Jewelry, and a Turkish bath, among others. A ground-floor store was occupied by Church and Morse Hardware, still in business on South Colony Street.

In 1939, the same area of Colony Street had paved roads and automobiles. The Home Bank Clock is on the west side of the street, and just to its right in the distance is the traffic tower in front of the Palace Block. Stores and offices abounded in this central business district.

By the time of this 1952 photograph, the Home Bank Clock was attached to the building. On February 26, 1957, a tragic fire destroyed the Palace Block and adjoining buildings; two lives were lost. Almost 300 firemen and policemen battled the blaze. Radio Station WMMW, which occupied part of the top floor, was displaced, as were apartment tenants, several dentists, Shulte's Cigar Store, the Far East Restaurant, and other establishments.

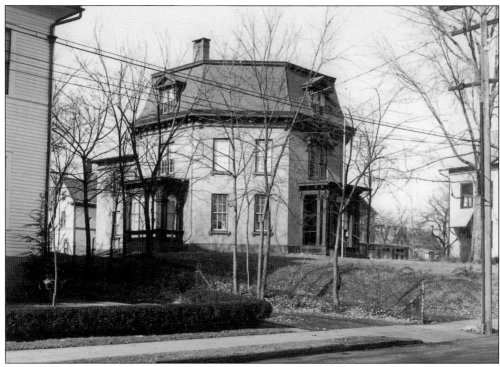

Originally a private residence, 30 Franklin Street housed the Disabled War Veterans Association when this image was taken in 1954. The structure fell to the construction of the new U.S. Route 66, which sliced across the city in the early 1970s. The east-west highway that links U.S. Interstate 91 to U.S. Interstate 84 is now called U.S. Interstate 691. In October 1988, the road was dedicated to former mayor and state senator Henry D. Altobello (1907–1988).

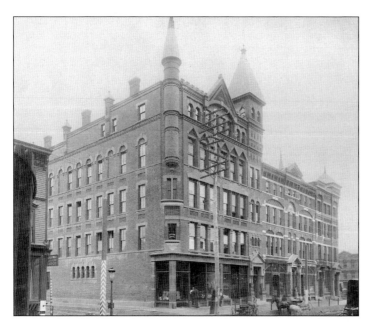

The City Mission Building was erected in 1888 at 69 East Main Street by Isaac C. Lewis. He presented it to the City Mission Society in 1889. It changed hands and names a number of times and was finally called the Century Building. The once elaborate architectural details were covered by metal sheathing, and it became progressively more rundown. It was razed in 1993, amidst controversy over whether it could be saved.

Meriden's sesquicentennial celebration took place in June 1956. The weeklong festivities brought out crowds of residents, visitors, and former residents to celebrate the 150th anniversary of the city. Church Day, School Day, Industrial Day, Governor's Day, Celebrity Day, Homecoming Day, and Community Day were featured from June 17 through 23. Pictured in this view is the parade on West Main Street, June 23, 1956.

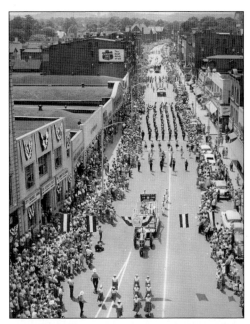

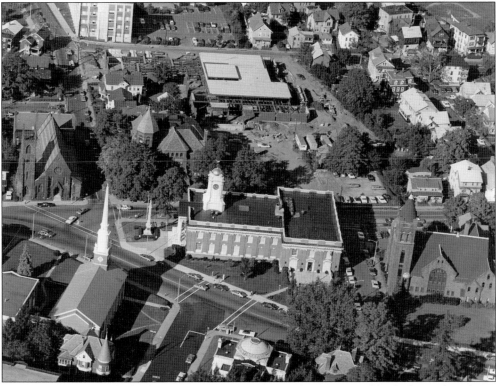

This 1972 aerial view looks down on East Main Street and vicinity. Visible clockwise from lower left are the First Methodist Church, the Curtis Memorial Library, the Universalist Church, the new library under construction, the board of education building, and St. Andrews Church. City hall is the largest building in the lower center. The Kennedy apartment building (formerly part of the Manning and Bowman factory) is on the top left.

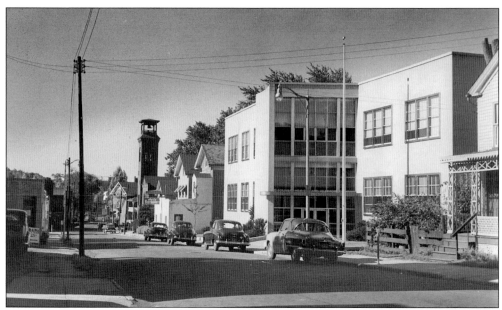

Visible on the right of this 1952 view of Butler Street are the Southern New England Telephone Company building, Neil's Restaurant, and in the distance, the tower of the fire department's Charter Oak Hose Company. Today the firehouse, minus the top part of its hose tower, has become King Travelways.

The Charter Oak Firehouse, constructed in late 1876 in the Romanesque Revival style, served the fire department until 1979. The tower was originally topped by a wooden bell cote. The building now houses King Travelways, founded by Roger and Jean King. The structure has been on the National Register of Historic Places since 1994.

When industrialist Clarence P. Bradley died in 1935, he left monetary funds and property to enable the establishment of a home for the aged. The Bradley Home was built in 1938. The main entry to the beautiful facility is on Wilcox Avenue. Expanded over the years, there is currently room for 104 residents.

Dr. Edward C. Newport (1837–1895) was a German-born physician and surgeon who lived and practiced in this house at 89 West Main Street. The 1892 city directory listed his office hours as 7:30 a.m. to 9:00 a.m., 1:30 p.m. to 2:30 p.m., and 7:00 p.m. to 9:00 p.m. By the 1920s, the house was gone, and a larger building had been erected.

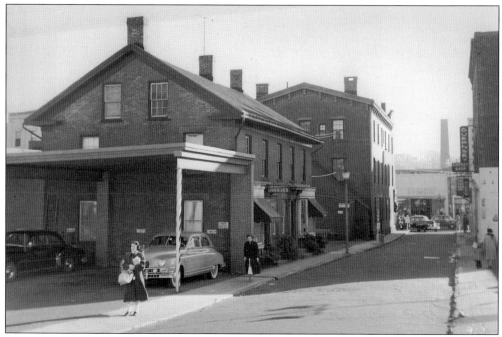

Shown here in 1951 when it housed the Phillips Dress Shop, the oldest building in the downtown area is located at One Barrister's Court. Earlier in the 20th century, it housed the Market Fair Tea Room and Heflin's Food Shop. Attorney Robert Sokolowski purchased the building in 1987 and had extensive renovations done to bring it back to its original look. Barrister's Court was formerly called High School Avenue.

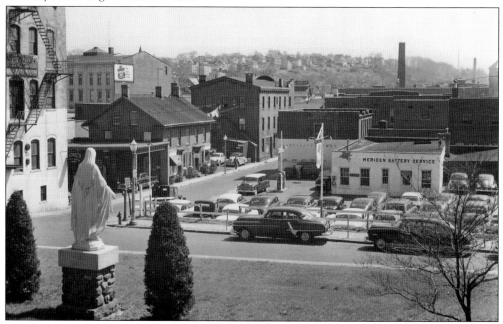

This 1954 view looks south onto what was then called High School Avenue and is now known as Barristers Court. A two-level parking garage is now on the site of the parking lot that is visible in front of Meriden Battery Service.

This ornate residence of Dr. Grove Herrick Wilson (1824–1902) was located on the west side of Colony Street, next to the First Congregational Church. Always civic minded, in addition to practicing medicine for 45 years, Dr. Wilson served as mayor and served two terms in the state legislature.

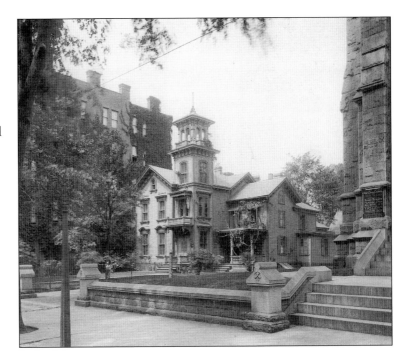

Lost to highway development in the early 1970s, Chestnut Street only exists on old maps and in pictures like this one from the 1890s. It ran from Columbia Street to a dead end that backed up to the Connecticut School for Boys property.

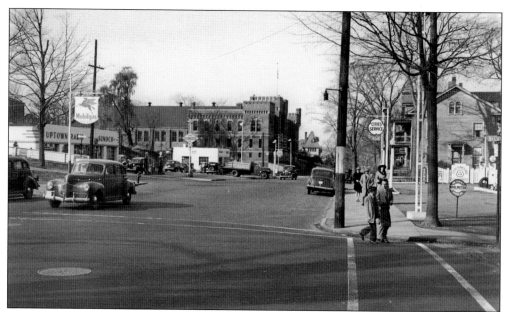

On November 24, 1946, this photograph of East Main Street was taken from the corner of Center Street looking west. People dressed in their Sunday best can be seen walking to St. Rose's Church. In the middle distance is the State Armory. Mobil, Sunoco, and Cities Service gas stations are all visible.

Looking west on Church Street in this 1951 view, one can glimpse the streamlined facade of the Ezzo Building at 86 Grove Street. Built by Modestino A. "Charlie" Ezzo in 1941, it was for many years home to the Meriden Bowling Lanes. Vacant in recent years, it was demolished in April 2009. St. Mary's Church and School can be seen on the right side of Church Street.

Nine

PUBLIC SERVICES

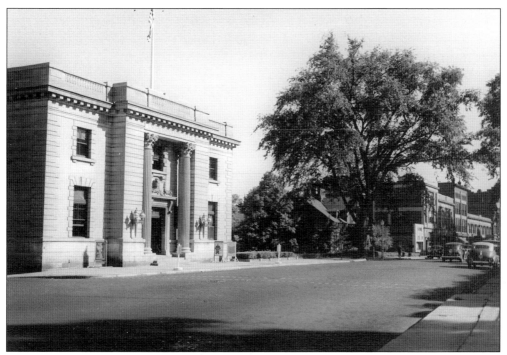

This 1946 view shows the former U.S. post office at 87 Colony Street. It opened in 1909, with Henry Dryhurst as postmaster. At that time, a 2¢ stamp was sufficient to mail a letter. The Beaux-Arts style structure was placed on the National Register of Historic Places in 1986. After the new post office opened on Center Street in 2007, the vacant building was sold to a commercial business.

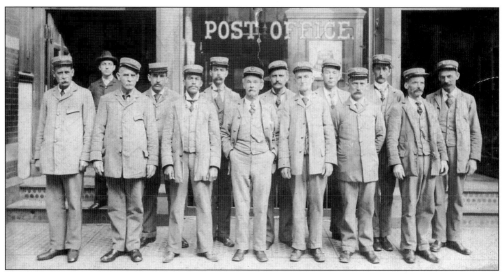

Posing here are postal carriers around 1900 when the post office was on the corner of Church and Colony Streets. From left to right are (first row) Christopher McEvoy, Charles Kelsey, John L. Jeffrey, William Seymour, William H. Minchin, George H. Rudolph, and Hugh Malley; (second row) Arthur Neveau, Louis H. Moses, George H. Packer, Wilbrod Germain, Patrick T. Fitzpatrick, Robert L. Mackay, and Walter H. Chalker.

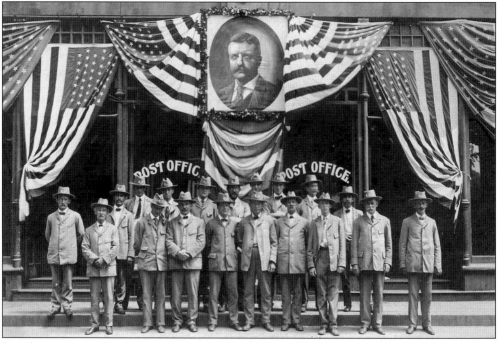

Postal carriers posed in front of the post office at 25 and 27 Colony Street in 1906. From left to right are (first row) William Seymour, George F. Hall, Eugene L. Root, Henry H. Fleischer, Patrick T. Fitzpatrick, Walter H. Chalker, Robert R. Reilly, Christopher McEvoy, and James M. Graves; (second row) George H. Rudolph, John L. Jeffrey, and Ernest E. Parkin; (third row) Walter A. Busch, Arthur Wesley Coates, Matthew McDonnell, David R. Bristol, William A. L'Hommedieu, Patrick J. Reardon, and William P. Jones

The Connecticut Police Academy trains and certifies police officers from Connecticut cities and towns. Pictured in this June 1971 photograph is the first graduating class from the newly built Preston Avenue facility in Meriden. In 1989, a memorial was erected on the grounds of the academy to honor all law enforcement officers who lost their lives while serving the citizens of the state of Connecticut. (Courtesy of Connecticut Police Academy.)

The State Armory on East Main Street was dedicated in 1908 amidst grand military pomp. In addition to housing Connecticut National Guard units, the building has hosted basketball games, boxing matches, and banquets. In 1923, Rudolph Valentino performed the tango for an audience of 700. In 1998, National Guard Unit Company C, 143rd Forward Support Battalion moved to the Waterbury Armory, leaving the building vacant.

In order to increase the Meriden water supply, land was acquired in Cheshire and the construction of Broad Brook Dam began in 1913. The largest of the city's reservoirs, it was placed in service in 1916. This c. 1928 photograph pictures the repair project that included removal of decomposed concrete and the casting on of a new facing. (Courtesy of Meriden Engineering Department.)

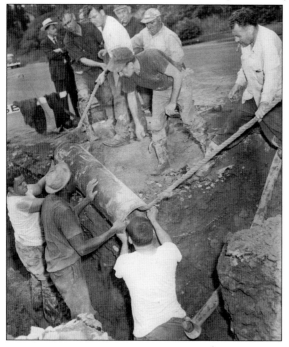

Water department workers are shown installing a larger main on Parker Avenue to improve the water pressure on the east side. Prior to 1869, all water was obtained from private wells. Local water service began with the construction of Merimere, the first reservoir. By the time this photograph was taken in 1954, there were more than 150 miles of water mains, about 700 hydrants, and 10,000 meters.

The city's first trade school opened in 1918 at the corner of Charles Street and Parker Avenue. This "new trade school" erected on Miller Street in 1931 was later renamed for Horace C. Wilcox. After 1962, when Wilcox Technical High School relocated, the building was remodeled to house the police station, health department, and courts. It was renamed in honor of Dr. John E. Stoddard. (Courtesy of Meriden Engineering Department.)

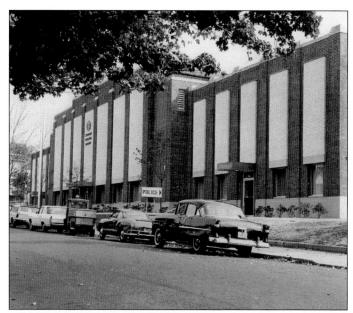

WMMW (Meriden Middletown and Wallingford), 1470 AM, was Meriden's hometown radio station for more than half a century. Begun in 1947, it originally occupied the entire fifth floor of the Palace Block on East Main Street. Although no longer broadcasting from the city, it remains on the air as an affiliate of WDRC, Connecticut's oldest radio station. Pictured is broadcaster John Zane (left) with unidentified colleagues. (Courtesy of Allen Weathers.)

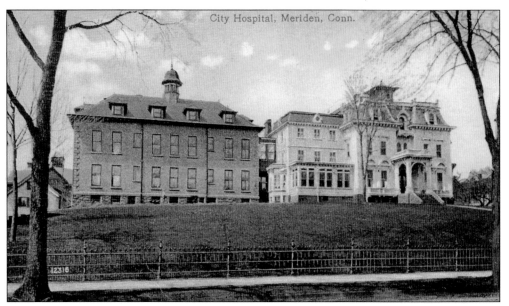

The first city hospital is depicted in this *c.* 1908 postcard. Meriden Hospital was chartered in 1885, and in February 1892 the former Jared Cook mansion (right) on Cook Avenue was purchased, with the first patient admitted later that year. The south wing (left) was added in 1905. Multiple additions and name changes sufficed until the new state-of-the-art MidState Medical Center opened on Lewis Avenue in 1998.

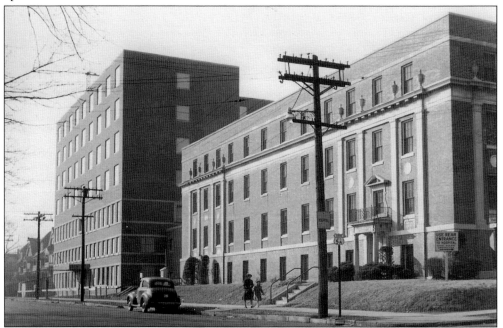

This is Meriden Hospital on Cook Avenue as it looked in 1950, with the Bradley Memorial Nurses Residence next door on the right. Renamed Meriden-Wallingford Hospital in 1969, it later merged with the east side World War II Veterans Memorial Hospital, and the name became Veterans Memorial Medical Center, with two campuses in use. The buildings shown here are currently vacant and await redevelopment.

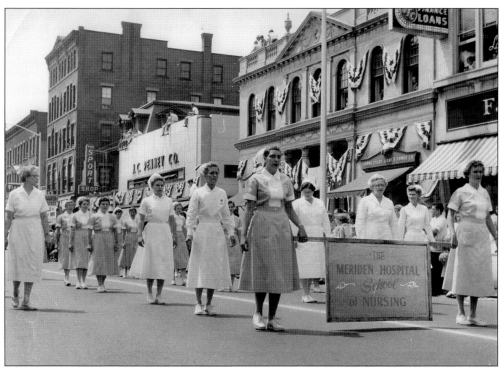

The first nurse training school at Meriden Hospital started in 1892, the year the hospital opened. The school of nursing closed in 1976. Student nurses are shown here marching on West Main Street in the sesquicentennial parade of June 1956. There is now an open plaza on the J. C. Penney building site where young people were perched to view the procession.

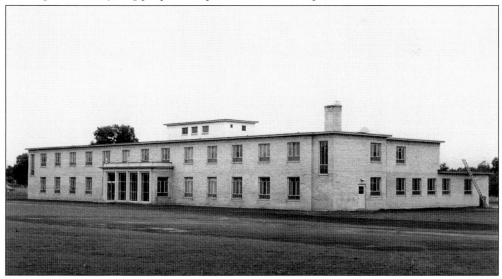

World War II Veterans Memorial Hospital is pictured here in 1954, the year it opened on Paddock Avenue. Dr. David P. Smith was the first chief of staff. The hospital included a chapel with photographs of the 147 men who perished in the war with pictures of soldiers who died in subsequent wars later added. The hospital merged with Meriden-Wallingford Hospital in 1991 and closed in 1998.

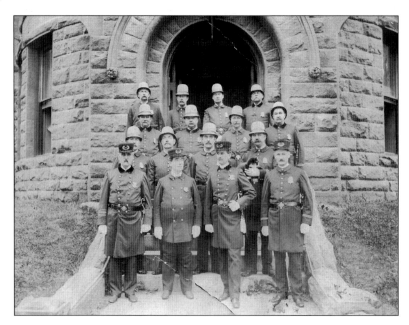

Mustaches seem to be part of the uniform for the city policemen pictured in this early 1900s view. Chief Charles B. Bowen is third from the left in the first row. He served as chief from 1906 until 1919. The patrolman in the second row, right, is holding a cat. (Courtesy of Allen Weathers.)

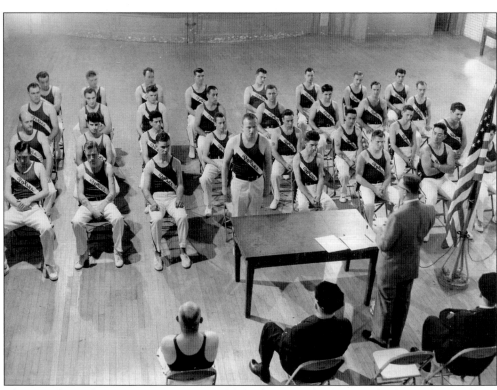

The Meriden Police Department was established in 1868 by Mayor Charles Parker. William Hagadon was the first chief; he was assisted by three patrolmen. By the time of this 1954 police recruit school photograph, there were 55 patrolmen, 16 officers, and five detectives.

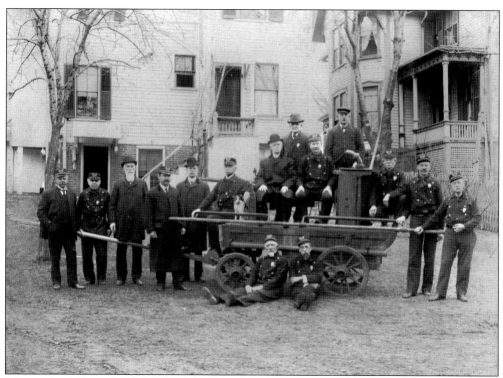

This early 1900s view of the Veteran Firemen's Association members features an old cataract engine. From left to right are (first row) bricklayer John Kane and George Page; (second row) state senator George N. Morse, John Barnes, Moss Breckenridge, Bernard Curran, James Curran, Albert A. May (with dog), Arthur Hughes, James Stetson, John D. Roberts Sr., Judson A. Hull, George N. Shepherd, John Milroy, and Charles Potter. (Courtesy of Allen Weathers.)

Parker Engine Company is the oldest Meriden firehouse still in use. Organized firefighting began in 1851, with firefighters first being paid in 1873. The Parker Hose Company No. 3 was organized in 1869 and had two prior locations before this Broad Street building was erected in 1889. It originally housed horse-drawn equipment, but by 1913 the department was mechanized. Pictured at right in 1892, the structure was renovated in 1996–1997.

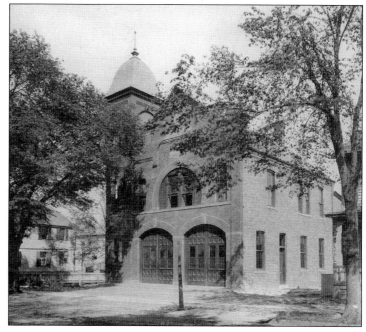

BIBLIOGRAPHY

Curtis, George Munson. *A Century of Meriden: A Historic Record and Pictorial Description of the Town of Meriden, Connecticut and the Men Who Have Made It, from Earliest Settlement to Close of its First Century of Incorporation.* Meriden, CT: Journal Publishing Company, 1906.

Davis, Charles Henry Stanley. *History of Wallingford, Conn., from its Settlement in 1670 to the Present Time: Including Meriden, Which Was One of its Parishes until 1806, and Cheshire, Which Was Incorporated in 1780.* Meriden, CT: self-published, 1870.

Hogan, Edmund P. *An American Heritage: A Book about the International Silver Company.* International Silver Historical Collection. Dallas, TX: Taylor Publishing Company, 1977.

Jette, Mark. *Century of Golf in Meriden 1898–1999.* Meriden, CT: self-published, 1999.

May, Earl Chapin. *Century of Silver, 1847–1947; Connecticut Yankees and a Noble Metal.* New York: R. M. McBride and Company, 1947.

——.*Meriden at 200: A Half-century of Change.* Meriden, CT: City of Meriden, 2006.

Rockey, John L. *History of New Haven County, Connecticut.* New York. W. W. Preston and Company, 1892.

Wendover, Sanford H. *150 Years of Meriden: Published in Connection with the Observance of the City's Sesquicentennial, June 17–23, 1956.* Meriden, CT: Meriden Sesquicentennial Committee, 1956.

INDEX